knitting
SHORT
ROWS

Techniques for Great
SHAPES & ANGLES

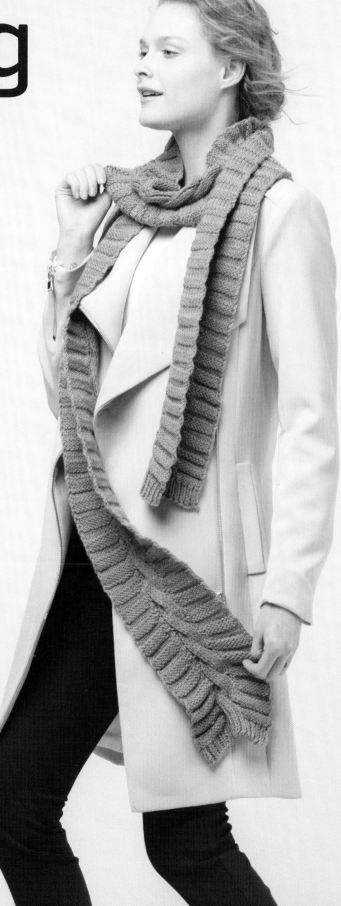

JENNIFER DASSAU

INTERWEAVE.
interweave.com

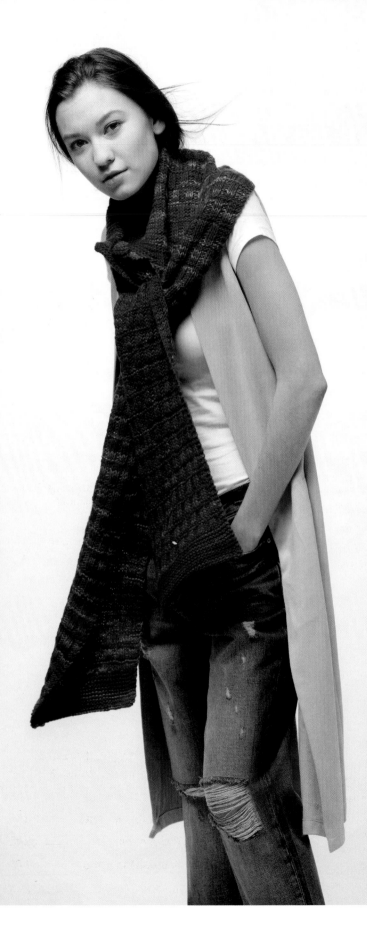

ACQUISITIONS EDITOR **Kerry Bogert**

EDITOR **Erica Smith**

TECHNICAL EDITOR **Daniela Nii**

DESIGNER **Charlene Tiedemann**

ILLUSTRATOR **Kathie Kelleher**

PHOTOGRAPHER **Harper Point Photography**

Knitting Short-Rows Copyright © 2016 by Jennifer Dassau. Manufactured in USA. All rights reserved. No part of this book may be reproduced in any form or by any electronic or mechanical means including information storage and retrieval systems without permission in writing from the publisher, except by a reviewer who may quote brief passages in a review. Published by Interweave Books, an imprint of F+W, A Content + eCommerce Company, 10151 Carver Road, Suite 200, Blue Ash, Ohio 45242. (800) 289-0963. First Edition.

fw

a content + ecommerce company

www.fwcommunity.com

19 18 17 5 4

Distributed in Canada by Fraser Direct
100 Armstrong Avenue
Georgetown, ON, Canada L7G 5S4
Tel: (905) 877-4411

Distributed in the U.K. and Europe by F&W MEDIA INTERNATIONAL
Brunel House, Newton Abbot, Devon,
TQ12 4PU, England
Tel: (+44) 1626 323200
Fax: (+44) 1626 323319
Email: enquiries@fwmedia.com

SRN: 16KN09
ISBN-13: 978-1-63250-258-2

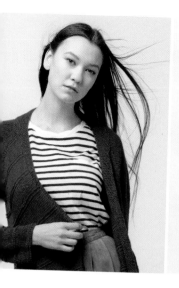
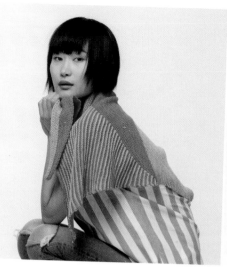
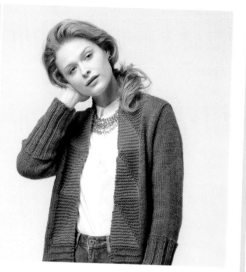

Contents

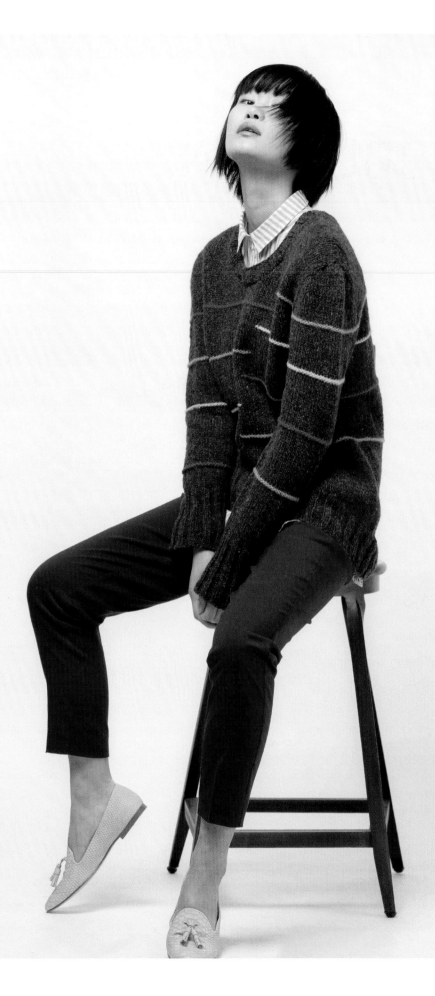

INTRODUCTION

Shape your knitwear seamlessly using short-row techniques, including wrap & turn, yarnover, German and Japanese methods, and twin stitch shadow wraps.

The beauty, ease, and charm of knitwear come in large part from its organic nature, from the curve of a sweater around the body, the depth and texture of a warm scarf, or the perfect slouch of a hat. I love designing knits that shape the fabric or create interesting detail using various knitting techniques. One of my favorite techniques of all is short-rows.

Short-rows are an invaluable technique that allow the knitter to create curves, angles, and depth, resulting in modern, seamless knitwear that is both engaging to knit and flattering to wear.

The book is intended to be both a technical learning resource and a beautiful design source that embodies modern, seamless knitting.

WHAT ARE SHORT-ROWS?

Short-rows are exactly that: partial rows in the knitting that create curves, soft angles, and depth.

All short-row techniques involve knitting a partial row, turning the work before the end is reached, and then knitting back in the opposite direction. When you again encounter the place where you've turned the work, which may be on the next row in that direction or many rows later, you will come to a small gap created at the turning point. This is because the last stitch before the turn is not connected to the stitch after it. Generally you don't want a hole in your knitting, so you have to do something to make the gap invisible. Different short-row techniques use various strategies, both when making the turn and when later closing the gap that has resulted. This book provides an in-depth look at five methods for knitting short-rows, presented in five chapters, each dedicated to one method. Each chapter includes step-by-step illustrated tutorials in stockinette stitch; an expanded discussion of applying each method in different pattern stitches, such as reverse stockinette, garter stitch, and working in the round; and three to five patterns, including garments and accessories. You can work your way through the whole book for a complete short-row primer or easily dip into the relevant chapter for a specific method.

WHEN TO USE SHORT-ROWS

Short-rows can make a sweater fit your three-dimensional shape or achieve a nontraditional shawl's interesting form. In garments, short-rows can be used instead of binding off stitches for shoulder or hem shaping or to add volume and length to part of the sweater. They can shape seamless garments without the need to knit in pieces that then require seaming, such as set-in sleeve caps. In shawls or accessories, short-rows can achieve interesting changes in the direction of knitting, making intriguing finished pieces. For practical fit purposes or for striking artistic expression, short-rows open up creative possibilities in your knitting.

WHICH SHORT-ROW METHOD TO USE?

When you knit short-rows, the goal is generally to work them so that they blend invisibly into the finished fabric, without leaving any holes or distortion. Which method to use depends on many factors, including your yarn composition, stitch gauge, stitch pattern, whether the wrong side will be showing, and personal preference. If one method isn't producing results you like for a particular project, then substitute another; you can employ different methods in different parts of your project, and even on different sides of the same short-row section. With an understanding of these five methods, knitting short-rows is a technique you can apply to any project. A discussion on substituting methods follows the five technique chapters.

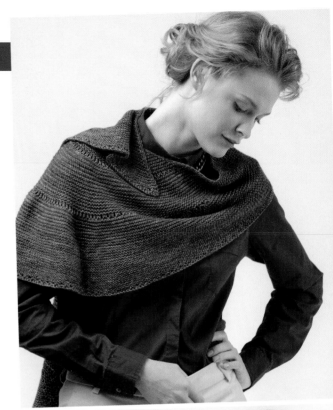

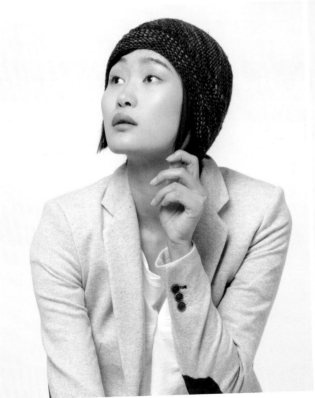

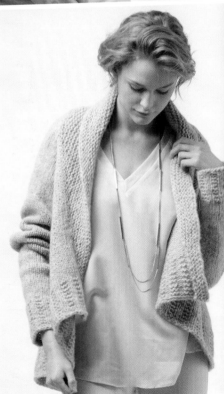

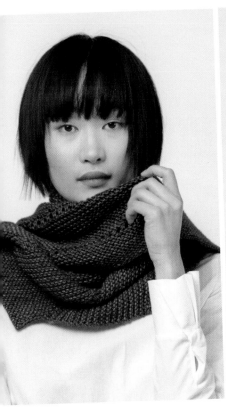

THE WRAP & TURN METHOD

The wrap & turn method, abbreviated as "w&t," is a simple and effective way to work short-rows back and forth in stockinette and garter stitch. It is also suitable for working pattern stitches and working in the round, with some considerations discussed below. In the w&t method, stitches are worked to one stitch before the desired turning point, then the turning stitch is slipped and wrapped with the working yarn, before turning the work. On a subsequent row, the wrapped yarn, which is called the wrap, may be worked along with the slipped stitch that it wraps, to disguise the turning point. This book uses the abbreviation "w&t" as the instruction to wrap a stitch and turn the work.

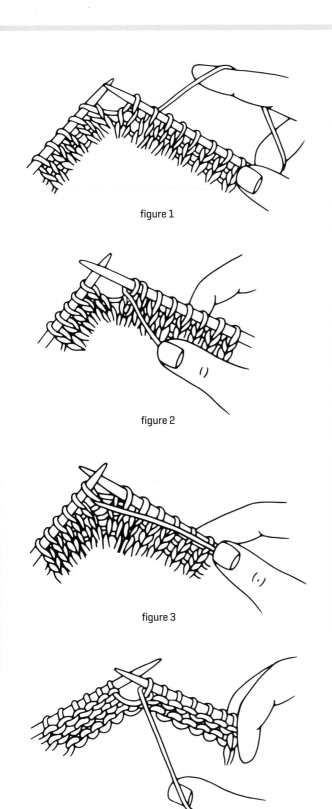

figure 1

figure 2

figure 3

figure 4

THE W&T METHOD ON A KNIT ROW

1 Knit to the turning point; with yarn in back, insert the right needle tip purlwise into the next stitch, and slip it to the right needle (**Figure 1**).

2 Bring the yarn to the front (**Figure 2**).

3 Slip the wrapped stitch back to the left needle (**Figure 3**).

4 Turn the work and work the next row. If you're working in stockinette stitch, bring the yarn to the front (**Figure 4**) and purl the next row. If you're working in garter stitch, leave the yarn in back when you turn the work and knit the next row.

THE W&T METHOD
ON A PURL ROW

1 Purl to the turning point; with yarn in front, insert the right needle tip purlwise into the next stitch and slip it to the right needle (Figure 1).

2 Bring the yarn to the back (Figure 2).

3 Slip the wrapped stitch back to the left needle (Figure 3).

4 Turn the work and work the next row. If you're working in stockinette stitch, bring the yarn to the back (Figure 4) and knit the next row. If you're working in garter stitch, every row is a knit row, and you'll be following the steps for w&t on a knit row instead.

In stockinette stitch, the wraps would be visible in the fabric if left untreated when you worked the wrapped stitch on a subsequent row. To avoid that, you can hide the wrap by picking it up with the needle and working it together with the wrapped stitch.

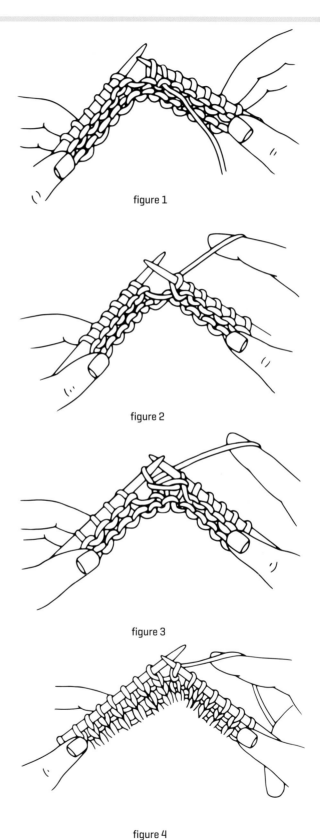

figure 1

figure 2

figure 3

figure 4

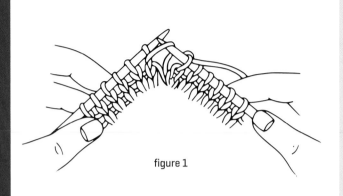

figure 1

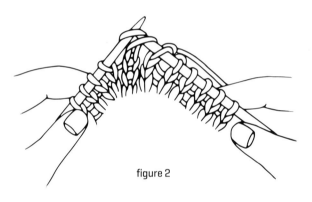

figure 2

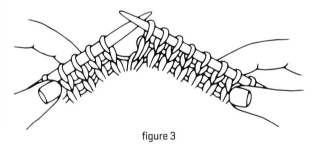

figure 3

TO PICK UP A WRAP ON A KNIT ROW

1 Insert the right needle tip knitwise into the front of the wrap (**Figure 1**).

2 Then insert the needle knitwise into the wrapped stitch (**Figure 2**).

3 Knit the wrap and the stitch together as one (**Figure 3**).

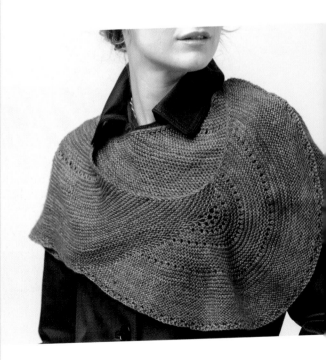

TO PICK UP A WRAP ON A PURL ROW

1 Insert the right needle tip purlwise into the back of the wrap (**Figure 1**).

2 Place the wrap onto the left needle (**Figure 2**).

3 Insert the right needle tip purlwise into both the wrap and the stitch (**Figure 3**).

4 Purl the wrap and the stitch together as one (**Figure 4**).

In garter stitch, there is generally no need to pick up the wraps, since they disappear into the textural garter fabric; just knit subsequent rows, leaving the wraps where they are. For this reason, I like the quick and easy wrap & turn method when I'm working garter stitch; the result is clean and cohesive across many yarn weights and fabric gauges.

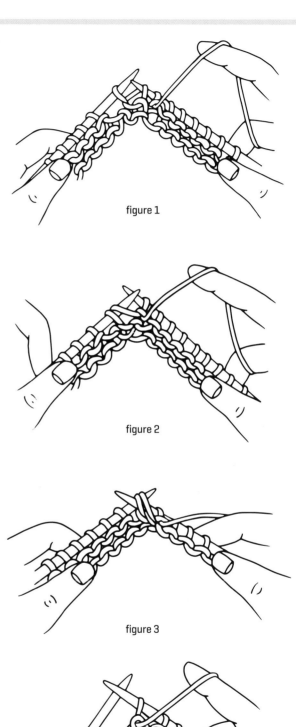

figure 1

figure 2

figure 3

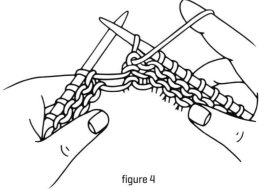

figure 4

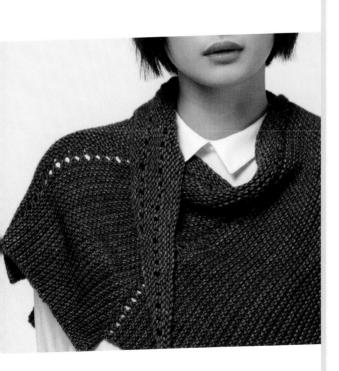

SPECIAL CONSIDERATIONS

The w&t method is excellent for simple pattern stitches such as ribbing, in which extra rows do not interrupt the flow of the patterning. Using the working yarn to disguise the turning point eliminates the need to borrow yarn from a stitch in the row below, which might distort the fabric. Placing the turning point such that you are wrapping a purl stitch may also allow you to leave the wrap unworked, as the wrapped purl stitch recedes into the ribbing or pattern fabric.

The w&t method is also suitable for working in the round, with a small adaptation when working the wraps. After a short-row section has been worked back and forth within a round of a project that is knit in the round, the final short-row will continue all the way to the completion of the round. Along the way, you will encounter some wraps that sit "backward" on the wrapped stitches—the wrap will originate from the left of the wrapped stitch and enclose the stitch on its right because you are approaching the stitch from the opposite direction in which it was wrapped. Simply insert the right needle tip into both the wrap and the stitch and work them together as one.

Depending on your yarn, w&t may not be the tidiest method when working in stockinette stitch because creating the wrap uses a significant amount of the working yarn, which can appear loose in the finished fabric. The standard method of picking up and working the wrap also places it on the purl side of the fabric, where it is visible. If the purl side will be showing or you're working in reverse stockinette, the wraps will be noticeable and not blend with the purl fabric, particularly if your yarn is less elastic, such as cotton or silk, or a heavier weight, such as bulky. To help improve this, you can pick up the wrap and work it together with the stitch in a way to ensure that it is placed on the knit side of the fabric.

To place the worked wrapped stitch on the knit side when picking up on a knit row, use the right needle tip to pick up the wrap from the back of the work and lift it onto the needle, then maneuver it over the stitch so that it sits to the left of the stitch; you might need to use your fingers to coax the stitch under the wrap. When you knit the wrap and the stitch together, the wrap will sit in front of the stitch as viewed from the knit side and will

be disguised on the purl side of the fabric.

To place the worked wrapped stitch on the knit side when picking up on a purl row, slip the wrapped stitch purlwise to the right needle, then use the left needle tip to lift the wrap onto the right needle and over the stitch and place it to its right. Slip both stitches back to the left needle and purl the wrap and the stitch together; the wrap will sit behind the stitch as viewed from the purl side and be disguised.

Employing this method basically unwraps the stitch by separating it from its wrap. It results in a purl stitch with a discreet double collar, thus improving the appearance of the purl side. However, it is very visible on the knit side; use it when only the reverse stockinette fabric is showing. Additionally, if you find it tedious to wrap the stitch and unwrap it later, then you might choose another method when using short-rows when the purl side of the fabric is visible.

earlappe HAT

The simplest of all short-rows, worked only
by turning, form the spiral wedges on the
crown of this sideways-knit hat. Stitches are
picked up from the lower edge and worked
in garter stitch in the round using the wrap
& turn method to shape the earflap brim;
no picking up of the wraps is needed!

FINISHED SIZE
One size to fit most adults; about
20" (51 cm) circumference and
9" (23 cm) height at earflap,
measured unstretched.

YARN
Aran weight (#4 Medium).

Shown here: Shalimar Yarns Equus
(100% superwash merino wool;
200 yd [183 m]/4 oz [114 g]):
Asilomar, 1 skein.

NEEDLES
Size U.S. 8 (5 mm): 16" (40 cm)
circular (cir) or 32" (60 cm) if using
Magic Loop. *Adjust needle size if
necessary to obtain the correct
gauge.*

NOTIONS
3 stitch markers (m); yarn needle;
scrap yarn for provisional CO.

GAUGE
16 sts and 36 rnds = 4" (10 cm) in
garter st.

Notes

The Earlappe Hat is knit sideways beginning with a provisional CO, which is grafted to the final row. I use the invisible provisional method and scrap yarn. Stitch gauge determines the height of the crown, while row gauge determines crown circumference; to adjust the size, work fewer or more spiral repeats. At the end of each RS short-row, turn the work without wrapping or otherwise preparing the stitches; the gap created by turning will be closed on the last RS row of each wedge by working stitches together. The gaps created by turning are easy to see; however, a stitch marker may be placed at each gap as a visual reminder if needed.

Stitch Guide

w&t (on a knit row) wrap & turn stitch: Slip stitch purlwise to right needle; move yarn to front, slip stitch back to left needle, turn work, move yarn to front.

w&t (on a purl row) wrap & turn stitch: Slip stitch purlwise to right needle; move yarn to back, slip stitch back to left needle, turn work, move yarn to back.

BABY CABLE

K2tog; without dropping the original two sts from left needle, insert right needle between them and knit the first st again; drop all sts from left needle.

CROWN

Using invisible provisional method (see Techniques), CO 36 sts.

SET-UP ROW: K32, place marker (pm), p2, pm, knit to end.

Spiral Wedge

SHORT-ROW 1: (RS) K2, sl m, k2, sl m, k1f&b, knit to last 3 sts, turn—1 st inc'd.

SHORT-ROW 2 (AND EVERY WS ROW 2–14): Knit to first m, sl m, p2, sl m, knit to end.

SHORT-ROWS 3, 7, AND 11: K2, sl m, work Baby Cable, sl m, k1f&b, knit to 3 sts before previous turning point, turn—1 st inc'd.

SHORT-ROWS 5, 9, AND 13: K2, sl m, k2, sl m, k1f&b, knit to 3 sts before previous turning point, turn—1 st inc'd.

ROW 15: K2, sl m, work Baby Cable, sl m, knit to 1 st before previous turning point, [k2tog, k1] 7 times, k1—7 sts dec'd, 36 sts rem.

ROW 16: Sl 1, knit to first m, sl m, p2, sl m, knit to end.

Work Spiral Wedge 7 more times, ending with a Row 15. Cut yarn, leaving a 24" (61 cm) tail.

Place provisionally CO sts on spare needle, correcting stitch mount as needed. Fold hat with WS facing together and hold needles parallel with CO sts in front and final row of sts behind; weave yarn tail under both legs of all slipped edge sts and pull tightly to close hole at crown, then graft using yarn tail and garter method, as follows:

SET-UP: Insert needle through first st on front needle purlwise, then through first st on back needle purlwise.

FRONT NEEDLE: Insert needle through first st knitwise and drop st off needle, then through next st purlwise, leaving st on needle.

BACK NEEDLE: Insert needle through first st knitwise and drop st off needle, then through next st purlwise, leaving st on needle.

Rep Front Needle and Back Needle steps until all sts are grafted, substituting following stockinette method on back needle sts only between markers:

BACK NEEDLE: Insert needle through first st purlwise and drop st off needle, then through next st knitwise, leaving st on needle.

EARFLAP BRIM

With RS facing and using new yarn, beg at graft, pick up and knit 80 sts from lower edge of hat, pm and join for working in the rnd.

RND 1: Purl.

RND 2: Knit.

Rep last 2 rnds twice more.

SET-UP SHORT-ROW 1: (RS) P24, w&t.

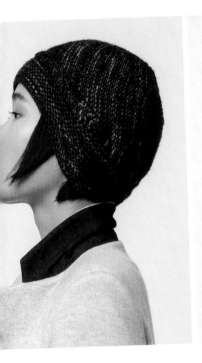
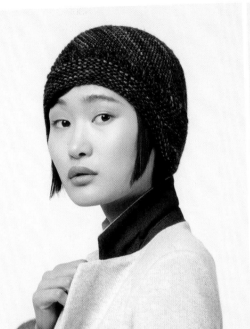
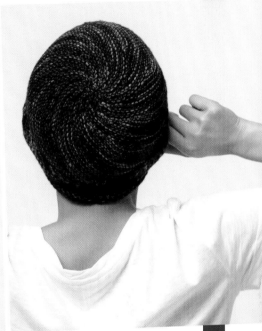

SET-UP SHORT-ROW 2: (WS) Purl to end of rnd, sl m; without turning, k24, w&t.

SHORT-ROW 1: (RS) Knit to end of rnd, sl m; without turning, purl to 1 st before previous wrapped st, w&t.

SHORT-ROW 2: (WS) Purl to end of rnd, sl m; without turning, knit to 1 st before previous wrapped st, w&t.

Rep Short-rows 1 and 2 once more.

Left Earflap

SHORT-ROW 1: (RS) K13, w&t.

SHORT-ROW 2: (WS) K12, w&t.

SHORT-ROW 3: K10, w&t.

SHORT-ROW 4: K9, w&t.

SHORT-ROW 5: K7, w&t.

SHORT-ROW 6: K6, w&t.

SHORT-ROW 7: K4, w&t.

SHORT-ROW 8: K3, w&t.

SHORT-ROW 9: K1, w&t.

Right Earflap

SHORT-ROW 1: (WS) K54, w&t.

SHORT-ROW 2: (RS) K12, w&t.

SHORT-ROW 3: K10, w&t.

SHORT-ROW 4: K9, w&t.

SHORT-ROW 5: K7, w&t.

SHORT-ROW 6: K6, w&t.

SHORT-ROW 7: K4, w&t.

SHORT-ROW 8: K3, w&t.

SHORT-ROW 9: K1, w&t.

SHORT-ROW 10: (RS) Knit to end.

NEXT RND: Purl.

NEXT RND: Knit.

Rep last 2 rnds twice more.

Bind off all sts purlwise.

FINISHING

Weave in ends and block.

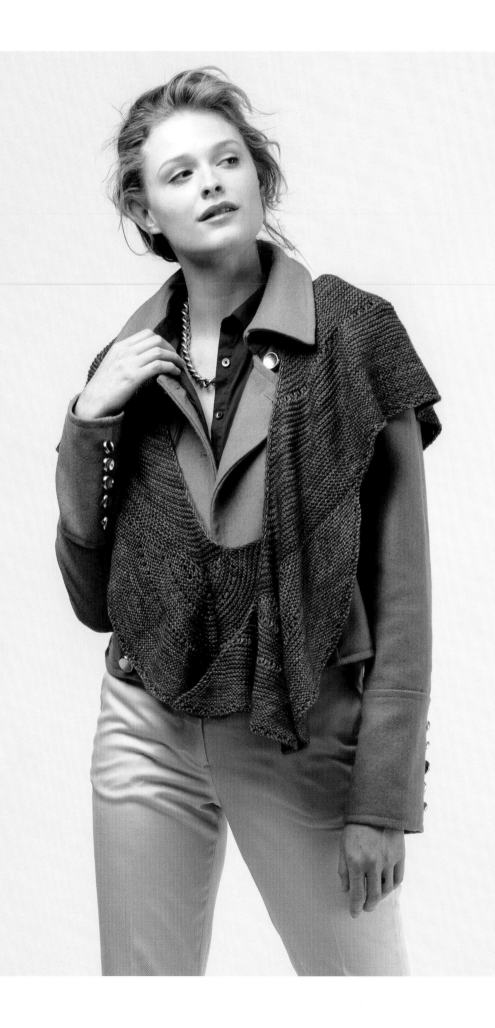

angel wings
SHAWLETTE

Three expanding arcs worked using
the wrap & turn method join seamlessly
into an angelic shawl. Using garter stitch
avoids the need to pick up wraps, while
eyelets add detail and shaping.

FINISHED SIZE
About 52" (132 cm) wide and 14"
(35.5 cm) deep.

YARN
Fingering weight (#1 Super Fine).

Shown here: String Theory Hand
Dyed Yarn Caper Sock (80% merino
wool, 10% cashmere, 10% nylon;
400 yd [366 m]/4 oz [113 g]):
Oban, 2 skeins.

NEEDLES
Size U.S. 6 (4 mm): 32" (80 cm)
and 60" (150 cm) circular (cir).
*Adjust needle size if necessary to
obtain the correct gauge.*

NOTIONS
2 stitch markers (m); yarn needle.

GAUGE
15 sts and 32 rows = 4" (10 cm) in
garter st.

Notes

This shawl is worked from the top down by casting on stitches for the length of the central body and working them with short-rows from the center out, until the edges are reached; the smaller wings are then created similarly on each side of the central section.

"Worked" includes both the stitches that have been actively incorporated from the CO by wrapping and turning and those added using yarnover increases. "Incorporated" refers to the stitches that have been added from the CO by wrapping them; "inc'd" refers to the stitches that have been added using yarnover increases. Every plain short-row adds one worked stitch; work to the last wrapped stitch, work the wrapped stitch, then wrap & turn the next stitch. There is no need to work the wrap together with the wrapped stitch in this garter shawl.

Circular needle is used to accommodate large number of sts. Do not join; work back and forth in rows, changing to longer needle when necessary.

Stitch Guide

w&t (on a knit row) wrap & turn stitch: Slip stitch purlwise to right needle; move yarn to front, slip stitch back to left needle, turn work, move yarn to front.

SHAWLETTE

Using cable method (see Techniques), CO 121 sts.

Knit 1 row.

SET-UP SHORT-ROW 1: K61, w&t.

SET-UP SHORT-ROW 2: K1 (center st), w&t—3 worked sts.

Central Section

SHORT-ROW 1: K2, w&t—1 st incorporated; 4 worked sts.

SHORT-ROW 2: (inc row) [Yo, k1] 3 times, w&t—1 st incorporated, 3 sts inc'd; 8 worked sts.

SHORT-ROW 3: K7, w&t—1 st incorporated; 9 worked sts.

SHORT-ROW 4: (inc row) [K1, yo] 6 times, k2, w&t—1 st incorporated, 6 sts inc'd; 16 worked sts.

KNIT SHORT-ROW: Knit to wrapped st, knit wrapped st without working wrap, w&t—1 st incorporated.

Rep Knit Short-row twice more—19 worked sts.

SHORT-ROW 8: (inc row) [K2, yo] 2 times, [k1, yo] 8 times, [k2, yo] 2 times, k2, w&t—1 st incorporated, 12 sts inc'd; 32 worked sts.

Rep Knit short-row 7 more times—39 worked sts.

SHORT-ROW 16: (inc row) [K2, yo] 6 times, [k1, yo] 12 times, [k2, yo] 6 times, k2, w&t—1 st incorporated, 24 sts inc'd; 64 worked sts.

Rep Knit short-row 15 more times—79 worked sts.

SHORT-ROW 32: (inc row) [K2, yo] 14 times, [k1, yo] 20 times, [k2, yo] 14 times, k2, w&t—1 st incorporated, 48 sts inc'd; 128 worked sts.

Rep Knit short-row 31 more times—159 worked sts.

SHORT-ROW 64: (inc row) [K2, yo] 30 times, [k1, yo] 36 times, [k2, yo] 30 times, k2, w&t—1 st incorporated, 96 sts inc'd; 256 worked sts.

Rep Knit short-row 54 more times, until all sts have been worked—310 worked sts.

First Wing

K266 to last 44 sts, place marker (pm), k44 to end; turn work and CO 23 sts using cable method.

SET-UP SHORT-ROW 1: K34, w&t.

SET-UP SHORT-ROW 2: K1 (new center st), w&t—3 worked sts.

Rep Central Section instructions up to Increase short-row 64.

NEXT ROW: Knit to end; all sts before m have been worked—160 worked sts.

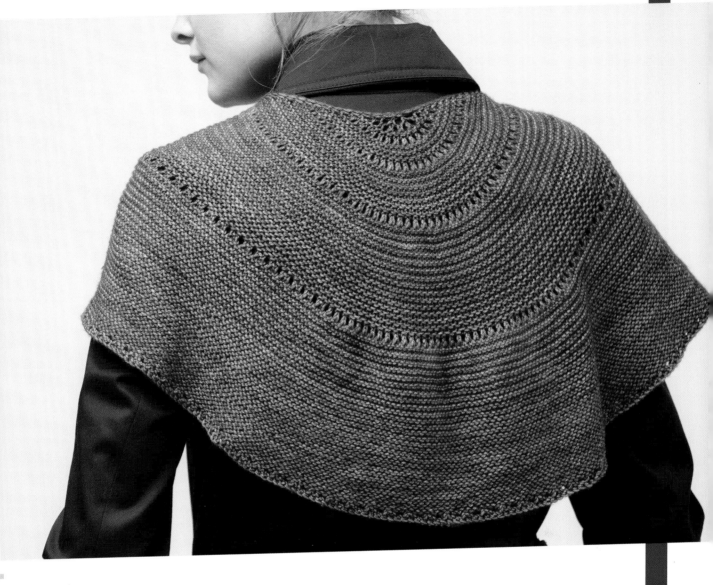

Second Wing

NEXT ROW: Knit to m, k222 to last 44 sts, pm, k44 to end; turn work and CO 23 sts using cable method.

SET-UP SHORT-ROW 1: K34, w&t.

SET-UP SHORT-ROW 2: K1 (new center st), w&t—3 worked sts.

Rep Central Section instructions up to Increase short-row 64.

NEXT ROW: Knit to end; all sts before m have been worked—160 worked sts.

NEXT ROW: Knit all sts to end, removing markers—542 sts.

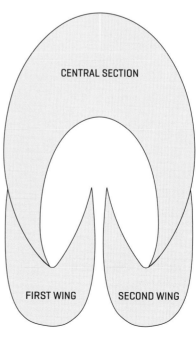

CENTRAL SECTION

FIRST WING SECOND WING

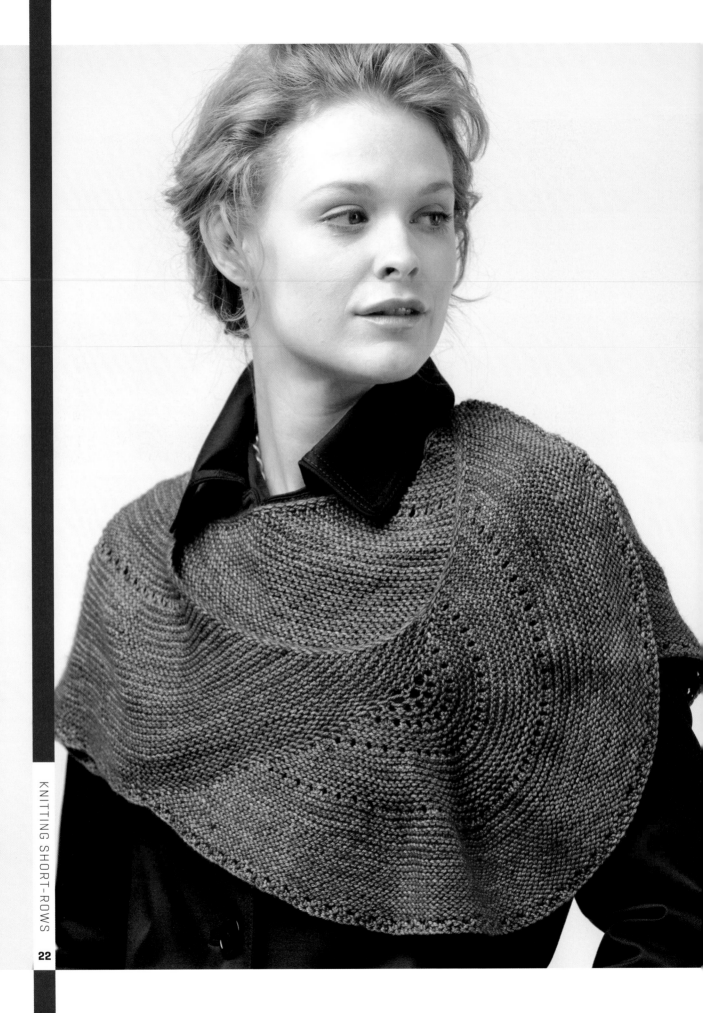

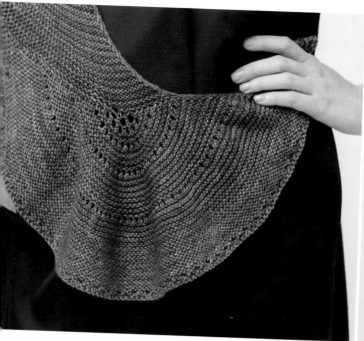

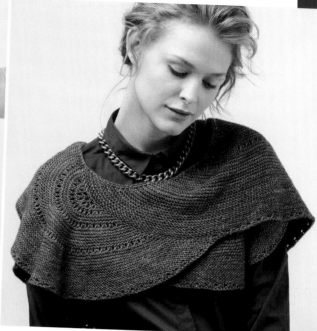

BORDER

ROW 1: Knit.

ROW 2: K1, yo, *k1, k2tog, k1, yo; rep from * to last st, k1.

ROW 3: Knit.

Bind off using stretchy k-tbl method, as follows:

K1, *k1, insert left needle through front of next 2 sts on right needle and k2tog-tbl; rep from * to end.

FINISHING

Weave in ends and block.

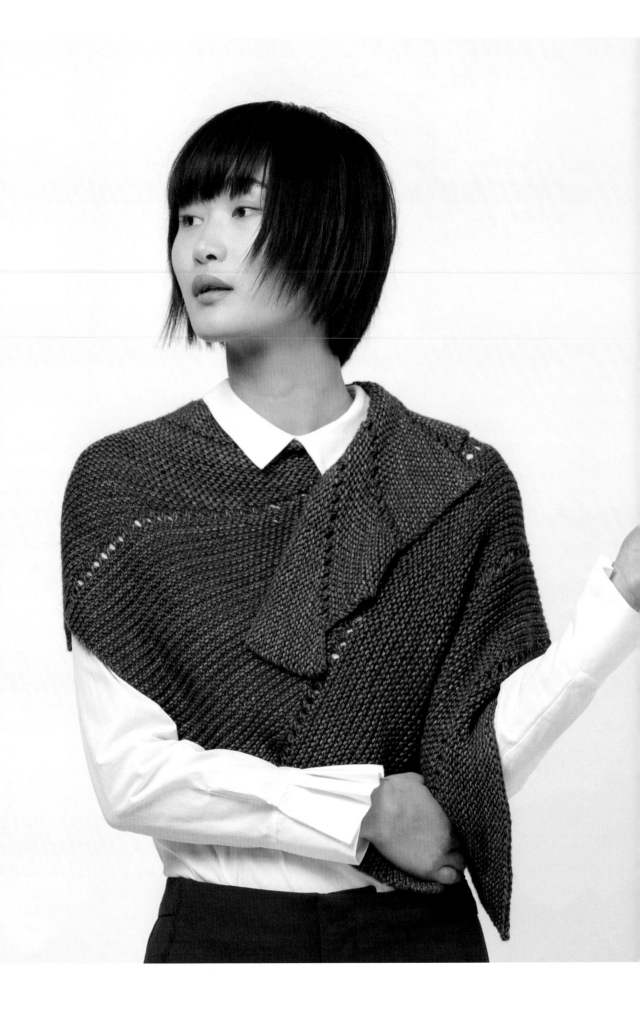

slices SHAWL

Sequential garter-stitch triangles
worked using the wrap & turn method
first increase then decrease in width,
growing ever longer to create a reversible
shawl. Wraps that require no picking up,
coupled with a worsted-weight yarn, make
an uncomplicated and speedy project.

FINISHED SIZE
About 68" [173 cm] wide and 21"
[53.5 cm] deep.

YARN
Worsted weight [#4 Medium].

Shown here: Dream in Color Classy
with Cashmere [70% merino wool,
20% cashmere, 10% nylon; 200 yd
[183 m]/4 oz [113 g]]: Visual
Purple, 3 skeins.

NEEDLES
Size U.S. 8 [5 mm]: 32" [80 cm]
circular [cir]. *Adjust needle size if
necessary to obtain the correct
gauge.*

NOTIONS
Yarn needle.

GAUGE
17 sts and 24 rows = 4" [10 cm] in
garter st.

Notes

There is no need to work the wrap together with the wrapped stitch in this garter shawl.

Circular needle is used to accommodate large number of sts. Do not join; work back and forth in rows.

Stitch Guide

w&t (on a knit row) wrap & turn stitch: Slip stitch purlwise to right needle; move yarn to front, slip stitch back to left needle, turn work, move yarn to front.

SHAWL

Using cable method (see Techniques), CO 38 sts.

Knit 1 row.

First Slice

SET-UP SHORT-ROW 1: Knit to last 3 sts, w&t.

SET-UP SHORT-ROW 2: Knit to end.

SHORT-ROW 1: Knit to 3 sts before previous wrapped st, w&t.

SHORT-ROW 2: Knit to end.

Rep Short-rows 1 and 2 until only 2 sts rem before last wrapped st.

Second Slice

INC ROW: BO 6 sts, knit to end; turn and CO 9 sts using cable method—41 sts.

YO ROW: K10, *yo, k2tog; rep from * to last st, k1.

Rep First Slice.

Third Slice

INC ROW: BO 6 sts, knit to end; turn and CO 12 sts using cable method—47 sts.

YO ROW: K12, *yo, k2tog; rep from * to last st, k1.

Rep First Slice.

Fourth Slice

INC ROW: BO 6 sts, knit to end; turn and CO 15 sts using cable method—56 sts.

YO ROW: K15, *yo, k2tog; rep from * to last st, k1.

Rep First Slice.

Fifth Slice

INC ROW: BO 6 sts, knit to end; turn and CO 18 sts using cable method—68 sts.

YO ROW: K19, *yo, k2tog; rep from * to last st, k1.

Rep First Slice.

Sixth Slice

INC ROW: BO 6 sts, knit to end; turn and CO 21 sts using cable method—83 sts.

YO ROW: K22, *yo, k2tog; rep from * to last st, k1.

Rep First Slice.

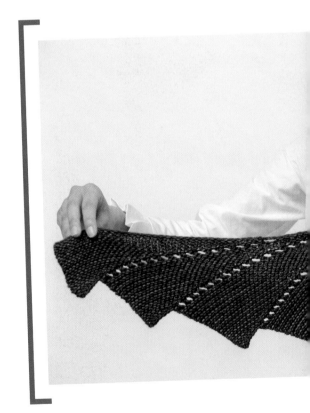

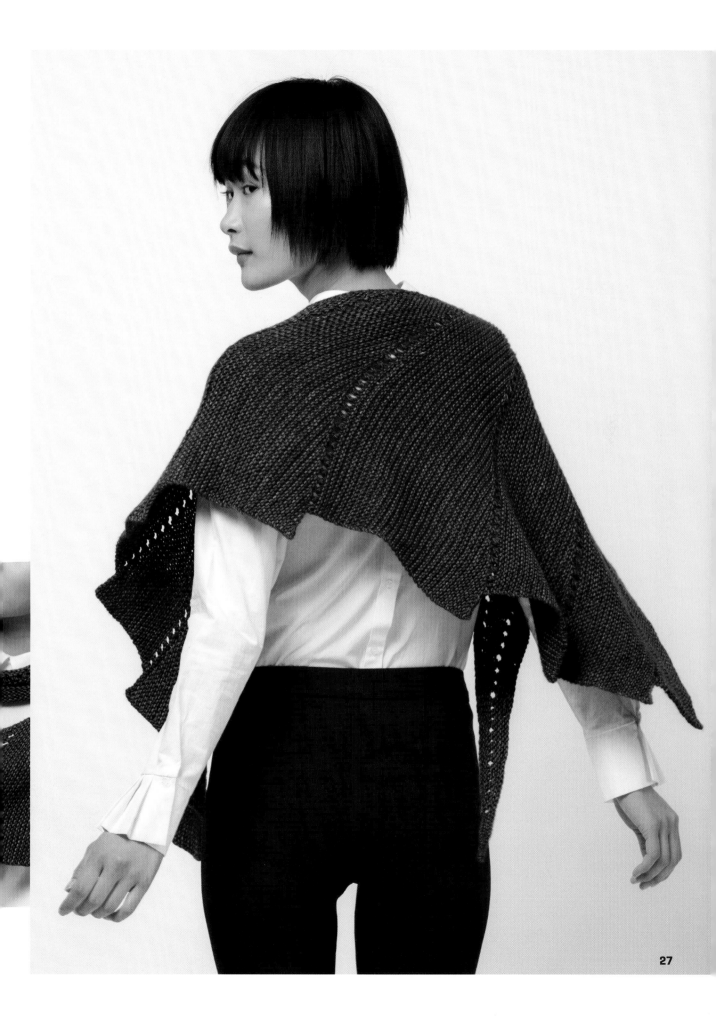

Seventh Slice

INC ROW: BO 6 sts, knit to end; turn and CO 24 sts using cable method—101 sts.

YO ROW: K24, *yo, k2tog; rep from * to last st, k1.

Rep First Slice.

Eighth Slice

INC ROW: BO 6 sts, knit to end; turn and CO 21 sts using cable method—116 sts.

YO ROW: K21, *yo, k2tog; rep from * to last st, k1.

SET-UP SHORT-ROW 1: Knit to last 4 sts, w&t.

SET-UP SHORT-ROW 2: Knit to end.

SHORT-ROW 1: Knit to 4 sts before previous wrapped st, w&t.

SHORT-ROW 2: Knit to end.

Rep Short-rows 1 and 2 until only 4 sts rem before last wrapped st.

Ninth Slice

INC ROW: BO 6 sts, knit to end; turn and CO 18 sts using cable method—128 sts.

YO ROW: K19, *yo, k2tog; rep from * to last st, k1.

SET-UP SHORT-ROW 1: Knit to last 6 sts, w&t.

SET-UP SHORT-ROW 2: Knit to end.

SHORT-ROW 1: Knit to 6 sts before previous wrapped st, w&t.

SHORT-ROW 2: Knit to end.

Rep Short-rows 1 and 2 until only 2 sts rem before last wrapped st.

Tenth Slice

INC ROW: BO 6 sts, knit to end; turn and CO 15 sts using cable method—137 sts.

YO ROW: K16, *yo, k2tog; rep from * to last st, k1.

SET-UP SHORT-ROW 1: Knit to last 9 sts, w&t.

SET-UP SHORT-ROW 2: Knit to end.

SHORT-ROW 1: Knit to 9 sts before previous wrapped st, w&t.

SHORT-ROW 2: Knit to end.

Rep Short-rows 1 and 2 until only 2 sts rem before last wrapped st.

FINISHING

BO all sts loosely. Weave in ends and block.

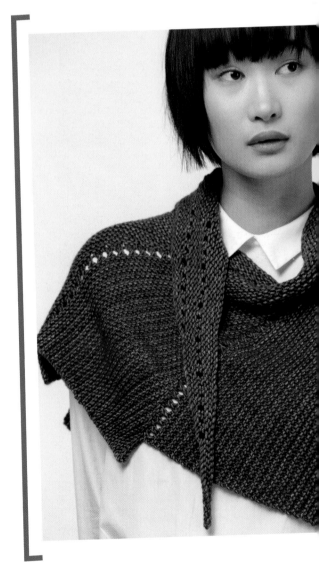

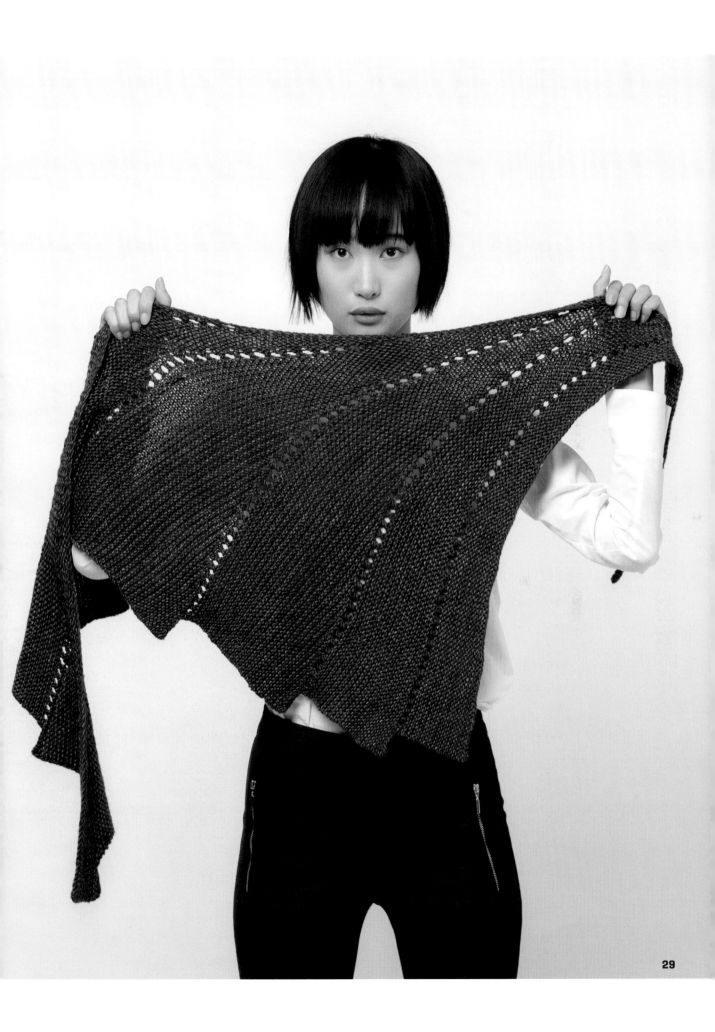

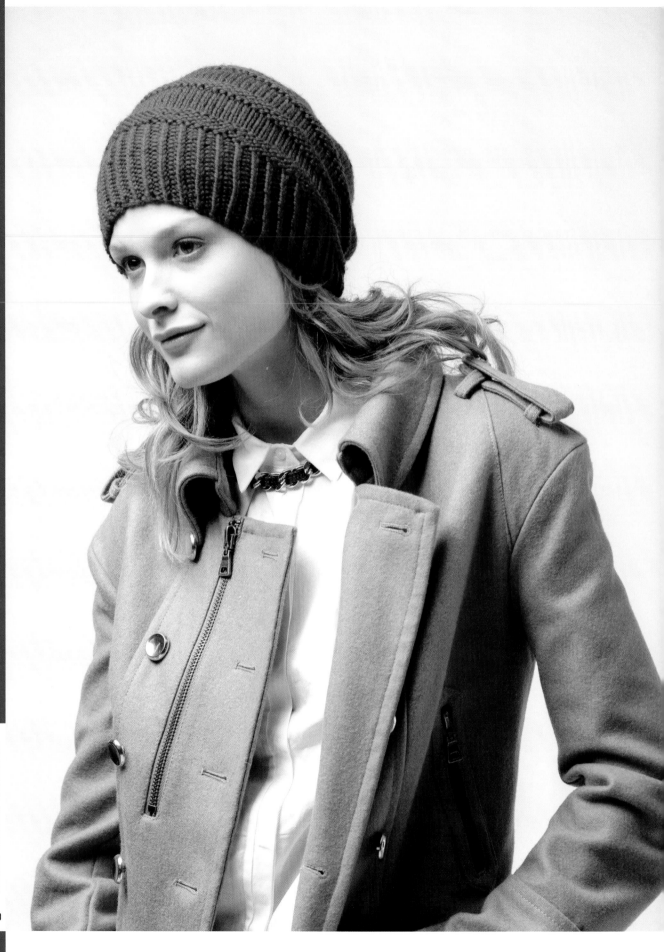

welter HAT

Short-rows worked using the
wrap & turn method within the twisted
ribbing pattern shape the brim of this hat
so that it hugs the nape; additional
short-rows between purl welts in the
crown add casual slouch.

FINISHED SIZE
One size to fit most adults; about
16" (40.5 cm) circumference
and 9" (23 cm) height, measured
unstretched.

YARN
Aran weight (#4 Medium).

Shown here: Lorna's Laces
Shepherd Worsted Solid (100%
merino wool; 225 yd (206 m)/4 oz
(113 g)): Manzanita, 1 skein.

NEEDLES
Size U.S. 7 (4.5 mm): 16" (40 cm)
circular (cir), or 32" (60 cm) if
using Magic Loop. *Adjust needle
size if necessary to obtain the
correct gauge.*

NOTIONS
9 stitch markers (m); yarn needle.

GAUGE
18 sts and 24 rnds = 4" (10 cm) in
St st.

Notes

Use w&t knit side instructions for RS; w&t purl side for WS. The short-rows of the brim are set up so that the wrapped stitch is always a purl stitch on the RS; there is no need to pick up that wrap as it disappears into the purl column of the ribbing. When working "to 4 sts before last wrapped stitch" you will work to the point where 4 plain sts, followed by the wrapped stitch, are on the left needle.

Stitch Guide

w&t (on a knit row) wrap & turn stitch: Slip stitch purlwise to right needle; move yarn to front, slip stitch back to left needle, turn work, move yarn to front.

w&t (on a purl row) wrap & turn stitch: Slip stitch purlwise to right needle; move yarn to back, slip stitch back to left needle, turn work, move yarn to back.

TWISTED RIB (worked flat, multiple of 2 sts)

Row 1: [RS] *K1-tbl, p1; rep from * to end.

Row 2: [WS] *K1, p1-tbl; rep from * to end.

Rep Rows 1 and 2 for patt.

TWISTED RIB (worked in the round, multiple of 2 sts)

Rnd 1: *K1-tbl, p1; rep from * to end.

Rep Rnd 1 for patt.

BRIM

Using cable method (see Techniques), CO 80 sts; place marker (pm) and join for working in the rnd, being careful not to twist sts.

Work Twisted Rib patt for 1" (2.5 cm).

SET-UP SHORT-ROW 1: (RS) *K1-tbl, p1; rep from * to 16 sts before m, k1-tbl, w&t.

SET-UP SHORT-ROW 2: (WS) *P1-tbl, k1; rep from * to 15 sts before m, p1-tbl, w&t.

SHORT-ROW 1: Work in patt to 2 sts before previous wrapped st, w&t.

Rep Short-row 1 nine more times.

NEXT ROW: (RS) Purl to end.

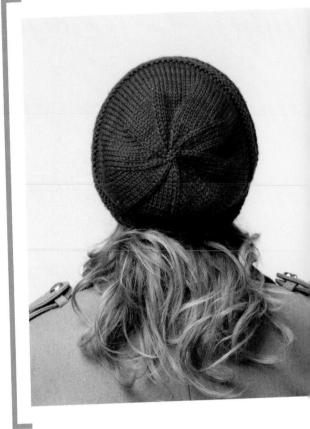

INC RND: *P7, p1f&b; rep from * to end—90 sts.

Purl 2 rnds.

Welt

Knit 3 rnds.

SET-UP SHORT-ROW 1: (RS) Knit to 16 sts before m, w&t.

SET-UP SHORT-ROW 2: (WS) Purl to 16 sts before m, w&t.

SHORT-ROW 1: Knit to 4 sts before previous wrapped st, w&t.

SHORT-ROW 2: Purl to 4 sts before previous wrapped st, w&t.

Rep last 2 short-rows once more.

NEXT ROW: (RS) Purl to end.

Purl 2 rnds.

Rep Welt once more.

Knit 15 rnds; hat measures about 2 ½" (6.5 cm) from last purl welt.

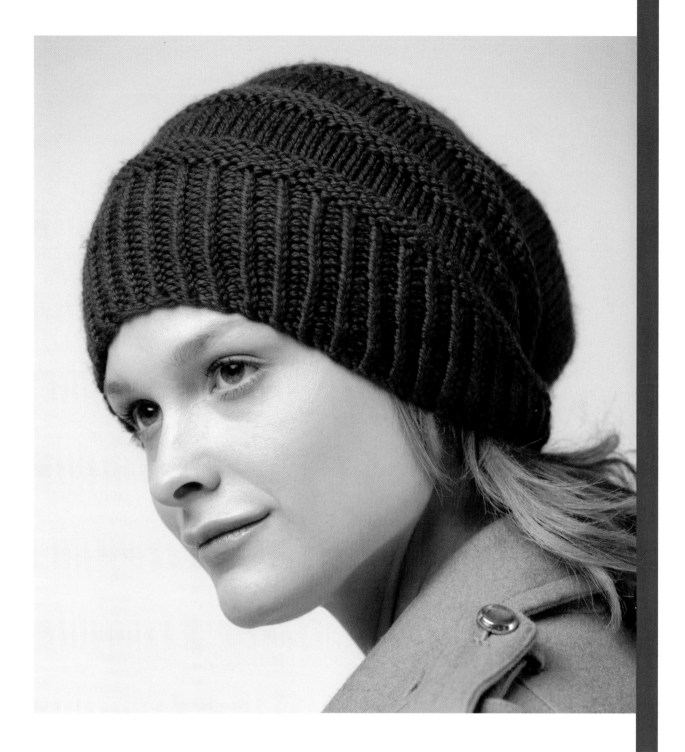

CROWN

SET-UP DEC RND: *K8, k2tog, pm; rep from * to last 10 sts, k8, k2tog—9 sts dec'd.

Knit 1 rnd.

DEC RND: *Knit to 2 sts before m, k2tog; rep from * to end—9 sts dec'd.

Rep Dec rnd every other rnd 5 more times; then rep Dec rnd once more—18 sts rem.

NEXT RND: *K2tog; rep from * to end—9 sts rem.

FINISHING

Cut yarn and pull through rem sts. Weave in ends and block.

curve wrap
CARDI

Cast on provisionally at the center back, this seamless blanket wrap is knit sideways in one piece to each front edge, with afterthought sleeves worked from live armhole stitches. Short-row shaping using the wrap & turn method shapes the bottom edge, and picking up the wraps makes an invisible transition to garter rib. The oversized garter-stitch shawl collar is picked up from the top edge and shaped with short-rows, using the wrap & turn method without picking up the wraps.

FINISHED SIZE
About 14½ (15, 16, 16½, 17½)" (37 [38, 40.5, 42, 44.5] cm) cross-back width; this cardi does not have a true bust circumference, choose a size based on cross-back measurement. Garment shown measures 15" (38 cm).

YARN
Chunky weight (#5 Bulky).

Shown here: Blue Sky Fibers Techno (68% alpaca, 22% silk, 10% merino wool; 120 yd [110 m]/1¾ oz [50 g]): Metro Silver, 9 (9, 10, 11, 12) skeins.

NEEDLES
Size U.S. 10½ (6.5 mm) and 9 (5.5 mm): 40" (100 cm) circular (cir). *Adjust needle size if necessary to obtain the correct gauge.*

NOTIONS
1 stitch marker (m); stitch holder; yarn needle; scrap yarn for provisional CO and afterthought sleeves.

GAUGE
12 sts and 20 rows = 4" (10 cm) in St st on larger needle; 12 sts and 26 rows = 4" (10 cm) in garter st on larger needle.

Stitch Guide

w&t (on a knit row) wrap & turn stitch: Slip stitch purlwise to right needle; move yarn to front, slip stitch back to left needle, turn work, move yarn to front.

w&t (on a purl row) wrap & turn stitch: Slip stitch purlwise to right needle; move yarn to back, slip stitch back to left needle, turn work, move yarn to back.

GARTER RIB (worked flat, multiple of 4 sts + 8)
Row 1: [RS] Knit.

Row 2: [WS] P3, [k2, p2] to last 5 sts, k2, p3.

Rep Rows 1 and 2 for patt.

GARTER RIB (worked in the rnd, multiple of 4 sts)
Rnd 1: Knit.

Rnd 2: *K2, p2; rep from * to end.

Rep Rnds 1 and 2 for patt.

RIGHT BACK

With larger needle, using invisible provisional method (see Techniques), CO 64 (69, 75, 78, 81) sts.

Knit 2 rows.

NEXT ROW: (RS) Knit.

NEXT ROW: (WS) Purl.

Work 32 (34, 36, 38, 40) more rows in St st as established, ending with a WS row; piece measures about 7¼ (7 ½, 8, 8¼, 8¾)" (18.5 [19, 20.5, 21, 22] cm) from CO edge.

RIGHT FRONT

NEXT ROW: (RS, divide for sleeve) K39 (43, 47, 49, 51); cut working yarn, leaving an 8" (20.5 cm) tail. With scrap yarn, knit next 22 (23, 25, 26, 27) sts; drop scrap yarn and with new main yarn, knit to end.

SET-UP SHORT-ROW: (WS) Purl to last st, w&t.

SHORT-ROW 1: (RS) Knit to end.

SHORT-ROW 2: (WS) Purl to 1 st before previous wrapped st, w&t.

Rep Short-rows 1 and 2 twenty-two (twenty-four, twenty-seven, twenty-eight, twenty-nine) more times until 40 (43, 46, 48, 50) sts remain unworked; piece measures about 9½ (10¼, 11½, 11¾, 12¼)" (24 [26, 29, 30, 32.5] cm) from sleeve divide.

Cut yarn and place all sts on holder.

LEFT BACK

Place 64 (69, 75, 78, 81) provisionally CO sts on larger needle and knit 2 rows, beg with a RS row.

NEXT ROW: (RS) Knit.

NEXT ROW: (WS) Purl.

Work 32 (34, 36, 38, 40) more rows in St st as established, ending with a WS row; piece measures about 7¼ (7 ½, 8, 8¼, 8¾)" (18.5 [19, 20.5, 21, 22] cm) from CO at center back.

LEFT FRONT

NEXT ROW: (RS, divide for sleeve) K3; cut working yarn, leaving an 8" (20.5 cm) tail. With scrap yarn, knit next 22 (23, 25, 26, 27) sts; drop scrap yarn and with new main yarn, knit to last st, w&t.

SET-UP SHORT-ROW: (WS) Purl to end.

SHORT-ROW 1: (RS) Knit to 1 st before previous wrapped st, w&t.

SHORT-ROW 2: (WS) Purl to end.

Rep Short-rows 1 and 2 twenty-two (twenty-four, twenty-seven, twenty-eight, twenty-nine) more times; 40 (43, 46, 48, 50) sts rem unworked; piece measures about 9 ½ (10¼, 11 ½, 11¾, 12¼)" (24 [26, 29, 30, 32.5] cm) from sleeve divide.

Do not cut yarn.

HEM

NEXT ROW: (RS) Knit 64 (69, 75, 78, 81) left front sts, working wraps together with wrapped sts; pick up and knit 56 (58, 62, 64, 66) sts from bottom edge of back; knit 64 (69, 75, 78, 81) right sts from holder, working wraps tog with wrapped sts—184 (196, 212, 220, 228) sts.

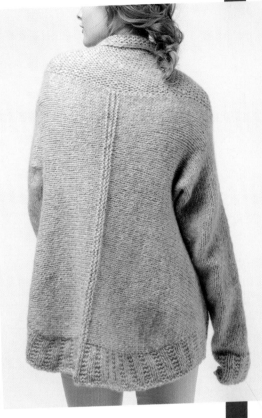

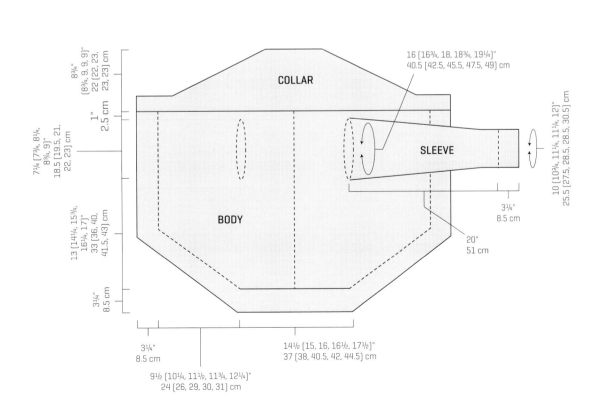

8¾"
[8¾, 9, 9, 9]"
22 [22, 23,
23, 23] cm

1"
2.5 cm

7¼ [7¾, 8¼,
8¾, 9]"
18.5 [19.5, 21,
22, 23] cm

13 [14¼, 15¾,
16¾, 17]"
33 [36, 40,
41.5, 43] cm

3¼"
8.5 cm

COLLAR

BODY

16 [16¾, 18, 18¾, 19¼]"
40.5 [42.5, 45.5, 47.5, 49] cm

SLEEVE

10 [10¾, 11¼, 11¼, 12]"
25.5 [27.5, 28.5, 28.5, 30.5] cm

3¼"
8.5 cm

20"
51 cm

3¼"
8.5 cm

14½ [15, 16, 16½, 17½]"
37 [38, 40.5, 42, 44.5] cm

9½ [10¼, 11½, 11¾, 12¼]"
24 [26, 29, 30, 31] cm

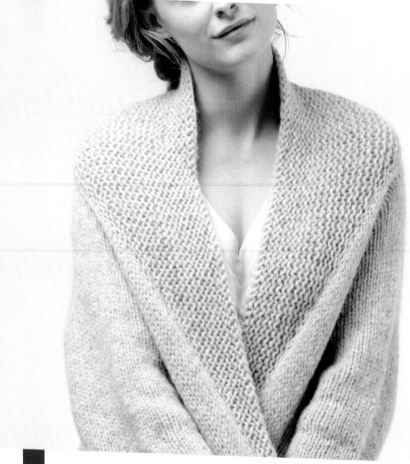
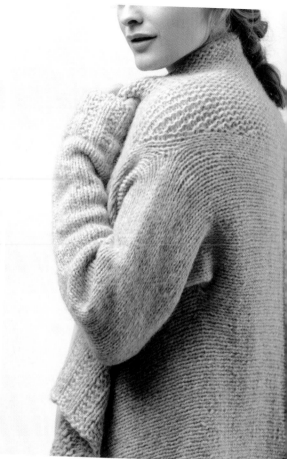

Note: Pick up about 3 sts for every 4 rows. The wraps on the stitches of the right front will be sitting backward; simply insert needle tip under both wrap and st and knit them together.

NEXT ROW: (WS) P3, [k2, p2] to last 5 sts, k2, p3.

ROW 1: (RS) Knit.

ROW 2: (WS) P3, [k2, p2] to last 5 sts, k2, p3.

Work in Garter Rib patt as established for 16 more rows; hem measures about 3¼" (8.5 cm) deep.

Bind off all sts purlwise on RS.

SLEEVES

Carefully cut 1 st of scrap yarn in middle of armhole, remove scrap yarn and place 45 (47, 51, 53, 55) live sleeve sts on larger needle.

With RS facing and beg at bottom of armhole, pick up and knit 1 st from body, knit to top of armhole, pick up and knit 2 sts from body, knit to end; place marker (pm) and join for working in the round—48 (50, 54, 56, 58) sts.

Knit 9 (9, 8, 7, 7) rnds.

DEC RND: K1, ssk, knit to 3 sts before m, k2tog, k1—2 sts dec'd.

Rep Dec rnd every 10 (10, 9, 8, 8) rnds 8 (8, 9, 8, 8) more times, then every 11 (11, 10, 9, 9) rnds 0 (0, 0, 2, 2) times total—30 (32, 34, 34, 36) sts rem.

Knit 10 more rnds.

Cuff

RND 1: Knit.

RND 2: *K2, p2; rep from * to end.

Work in Garter Rib patt as established for 16 more rnds.

Bind off all sts purlwise.

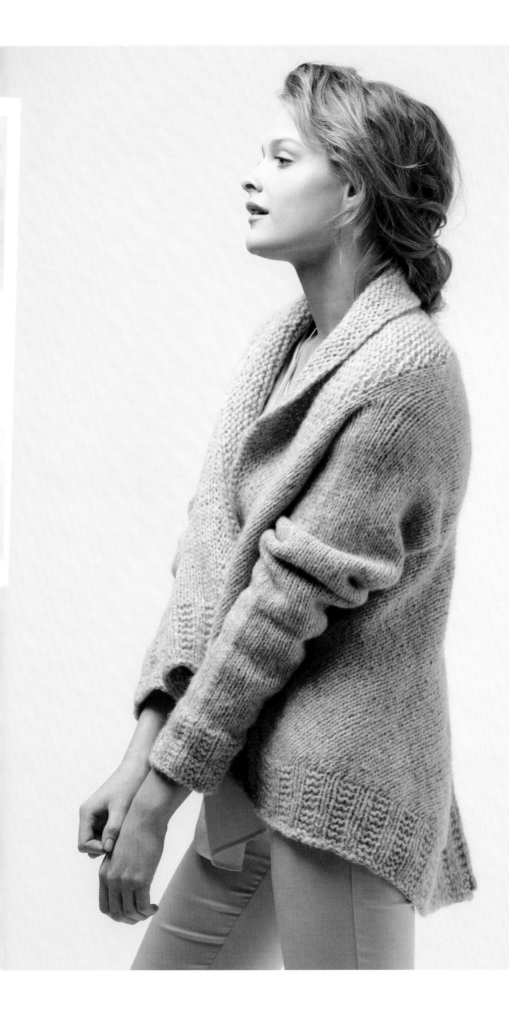

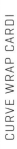

COLLAR

Note: Pick up about 2 sts for every 3 rows.

With smaller needle and beg at right front edge with RS facing, pick up and knit 12 sts along edge of garter ribbing, 56 (60, 65, 68, 71) sts along edge to center back, pm, 56 (60, 65, 68, 71) sts along edge to garter ribbing, and 12 sts along edge of garter ribbing—136 (144, 154, 160, 166) sts.

With larger needle, knit 1 row.

SET-UP SHORT-ROW: (RS) Knit to m, k9 (11, 13, 15, 17), w&t.

SET-UP SHORT-ROW: (WS) Knit to m, k9 (11, 13, 15, 17), w&t.

SHORT-ROW 1: (RS) Knit to previous wrapped st, k2, w&t.

SHORT-ROW 2: (WS) Knit to previous wrapped st, k2, w&t.

Rep Short-rows 1 and 2 twenty-two (twenty-two, twenty-three, twenty-three, twenty-three) more times, until 12 (14, 15, 16, 17) sts rem unworked at each end.

NEXT ROW: (RS) Knit to end.

NEXT ROW: (WS) Knit to end.

Knit 4 more rows.

Bind off all sts purlwise on RS.

FINISHING

Weave in all ends and block, paying particular attention to smoothing the curved sections of the garter-rib hem.

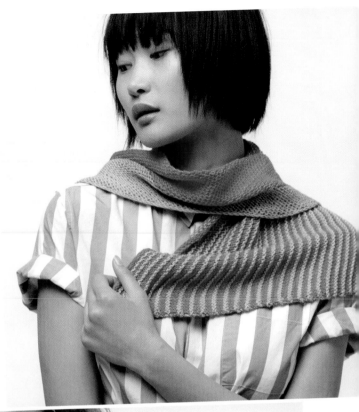

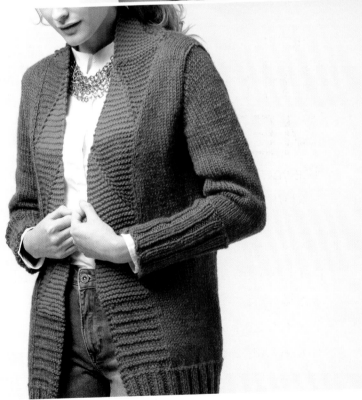

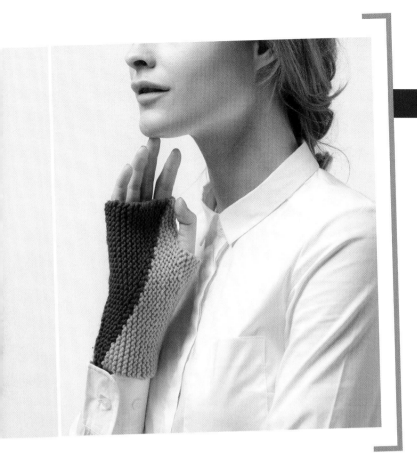

Chapter Two

THE YARNOVER METHOD

The yarnover, or "YO," method is easy to work back and forth in stockinette, garter, and rib and yields tidy results. In the yarnover method, stitches are worked to the desired turning point, the work is turned, then a backward yarnover is created with the working yarn. On a subsequent row, the yarnover is worked together with its neighboring stitch, to disguise the turning point. When working the yarnover, you will either twist or untwist it to achieve the necessary placement of the extra loop in the fabric.

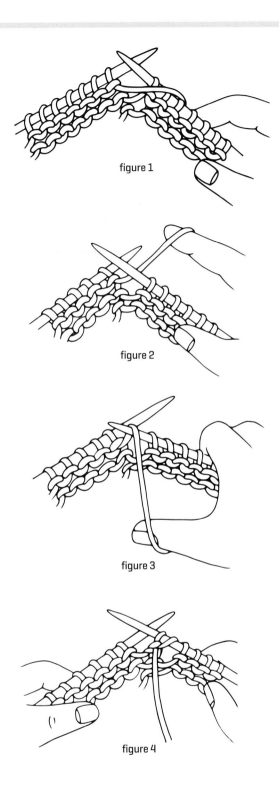

figure 1

figure 2

figure 3

figure 4

THE YARNOVER METHOD ON A KNIT ROW

1 Knit to the turning point and turn the work (**Figure 1**).

2 Make a backward yarnover by bringing the yarn between the needles to the back (**Figure 2**); the resulting YO will be twisted.

3 If you're working in stockinette, bring the yarn over the right needle to the front again and purl (**Figures 3 and 4**). Hold the YO in place with your finger if necessary while purling the first stitch. If you're working in garter stitch, bring the yarn over the right needle to the front, then between the needles to the back again, and knit.

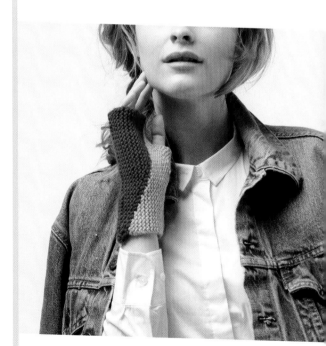

THE YARNOVER METHOD ON A PURL ROW

1 Purl to the turning point and turn the work (Figure 1).

2 Make a backward YO by bringing the yarn between the needles to the front (Figure 2).

3 Bring the yarn over the right needle to the back again (Figure 3) and knit (Figure 4); the resulting YO will not be twisted.

Each yarnover creates an extra loop, which in stockinette stitch must be remounted before working it together with its companion stitch, in order to place the loop invisibly on the back of the work.

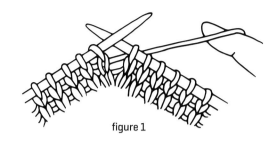

figure 1

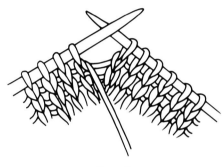

figure 2

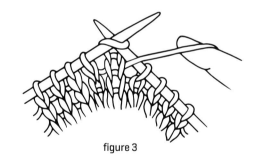

figure 3

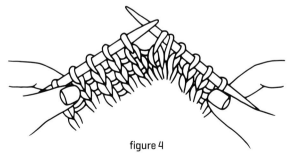

figure 4

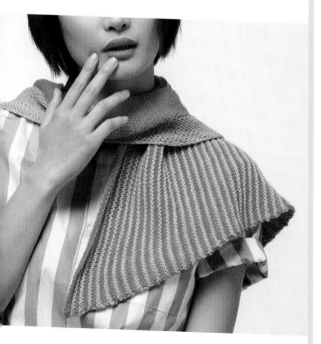

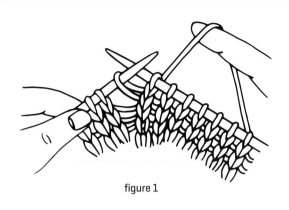

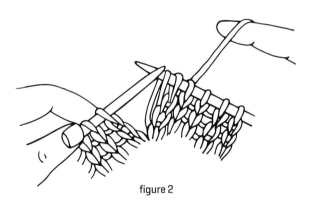

figure 1

TO WORK THE YARNOVER ON A KNIT ROW

1 Knit to the backward-mounted YO (**Figure 1**); slip the YO knitwise to the right needle by inserting the right needle tip under the leading stitch leg that is mounted behind the left needle, correcting the stitch mount (**Figure 2**).

2 Return the YO to the left needle without twisting it (**Figure 3**).

3 Knit the YO together with the next stitch (**Figure 4**).

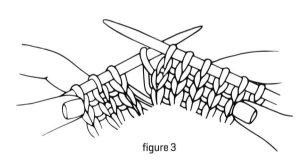

figure 2

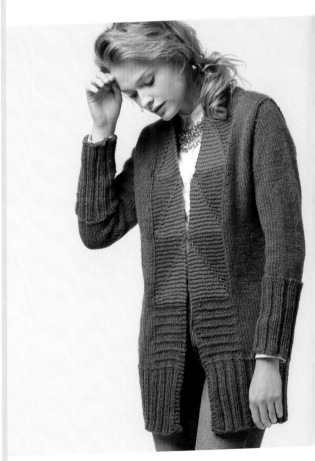

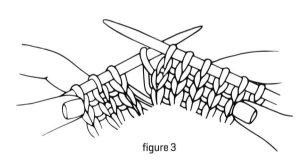

figure 3

figure 4

TO WORK THE YARNOVER ON A PURL ROW

1 Purl to the YO (**Figure 1**); slip the YO knitwise to the right needle, twisting it (**Figure 2**).

2 Slip the next stitch knitwise to the right needle, twisting it (**Figure 3**).

3 Return both the stitch and the YO to the left needle; both are twisted (**Figure 4**).

4 Purl the YO together with the next stitch through the back loops (**Figure 5**).

This yarnover method is effective in stockinette stitch, particularly on the right side of the work, but may appear sloppy on the reverse due to working the yarnover and its companion such that the yarnover loop is visible on the purl side. When working in reverse stockinette, where the purl side of the fabric will be visible, use a slight variation in working the yarnover.

To work the yarnover on a knit row in reverse stockinette, do not correct the stitch mount of the YO; slip the YO knitwise as it appears, keeping the leading leg mounted behind the needle, then slip the next stitch knitwise, twisting it as well. Return both the twisted YO and stitch to the left needle and knit them together through the back loops. The yarnover will be on the knit side of the work, invisible from the public side.

To work the yarnover on a purl row in reverse stockinette, do not twist the yarnover and the stitch; simply purl them together. The yarnover again will be visible from the knit side and hidden on the public purl side of the fabric. In all cases, be sure to make the yarnover itself tight around the needle, to minimize untidiness.

The yarnover method is simple to work on both sides of the fabric, and the yarnover itself is easy to see when it's time to work it with its companion on a following row. Since this method places extra loops of yarn over the needle, always be alert for the yarnovers and make sure not to count them as stitches when working your pattern.

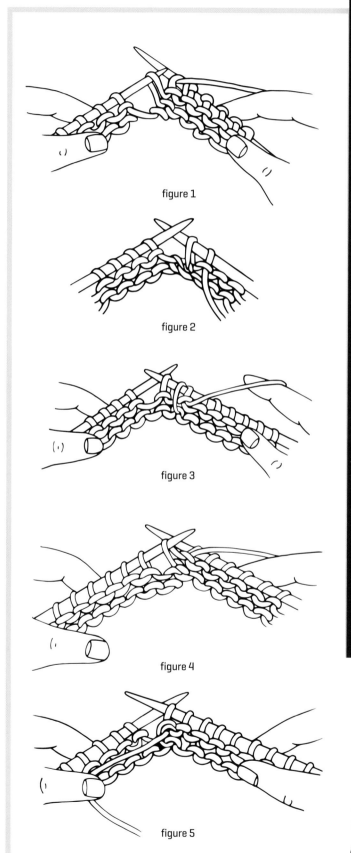

figure 1

figure 2

figure 3

figure 4

figure 5

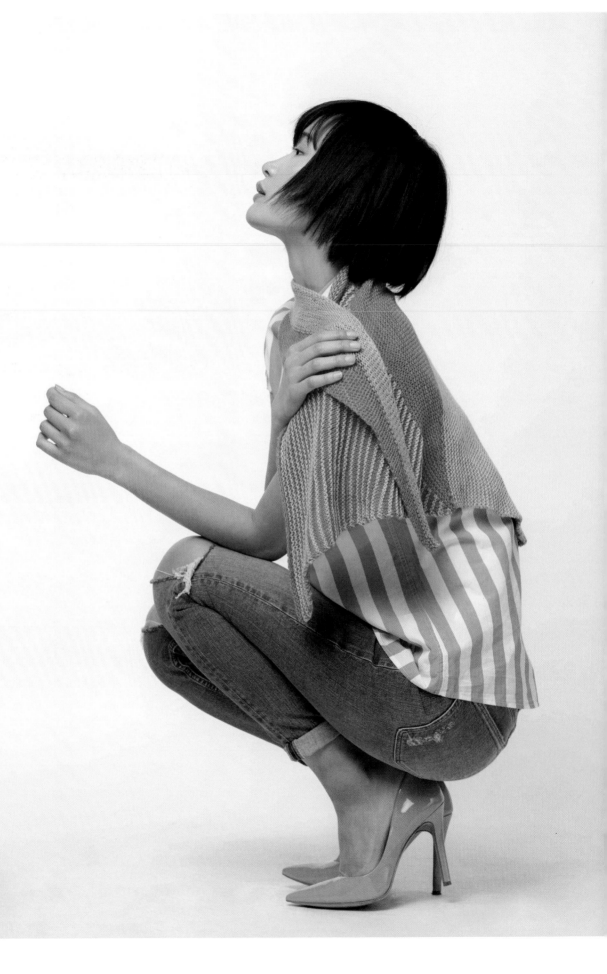

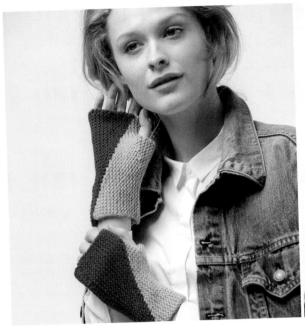

SPECIAL CONSIDERATIONS

Since this method does not involve working into the row below, there is no distortion, and thus it is well suited to working back and forth in garter stitch as well as stockinette and can be inserted between pattern-stitch rows. It is also suitable for colorwork where the yarn color changes between the row on which the yarnovers are made and the subsequent row where they are eliminated.

Using the yarnover method to work in the round is a bit more complicated because when you finally come around to the short-rows that were worked in the opposite direction, the yarnover appears after the stitch with which it must be worked in order to close the gap at the turning point. The principle is the same, but more manipulation is required; you will work to the stitch before the yarnover because this is the stitch that must be worked together with the yarnover. If necessary, slip this stitch to the right needle and correct the stitch mount, then slip the stitch back to the left needle and work it together with the yarnover as follows:

If you're working in stockinette, the round is a knit round; work to the stitch before the YO, then SSK.

If you're working in reverse stocki-nette, the round is a purl round; work to the stitch before the YO and slip it purlwise to the right needle, correct the stitch mount of the yarnover, then p2tog.

In garter stitch worked in the round, knit and purl rounds are alternated, which means you need to keep track of where you are in the pattern stitch when working the yarnover. A yarnover created in a knit row will be twisted; when you encounter the yarnover on a following purl round, work to the stitch before the YO and slip it purlwise to the right needle; correct the stitch mount of the yarnover, then p2tog. A yarnover created in a purl row will not be twisted; when you encounter the yarnover on a following knit round, work to the stitch before the YO and SSK.

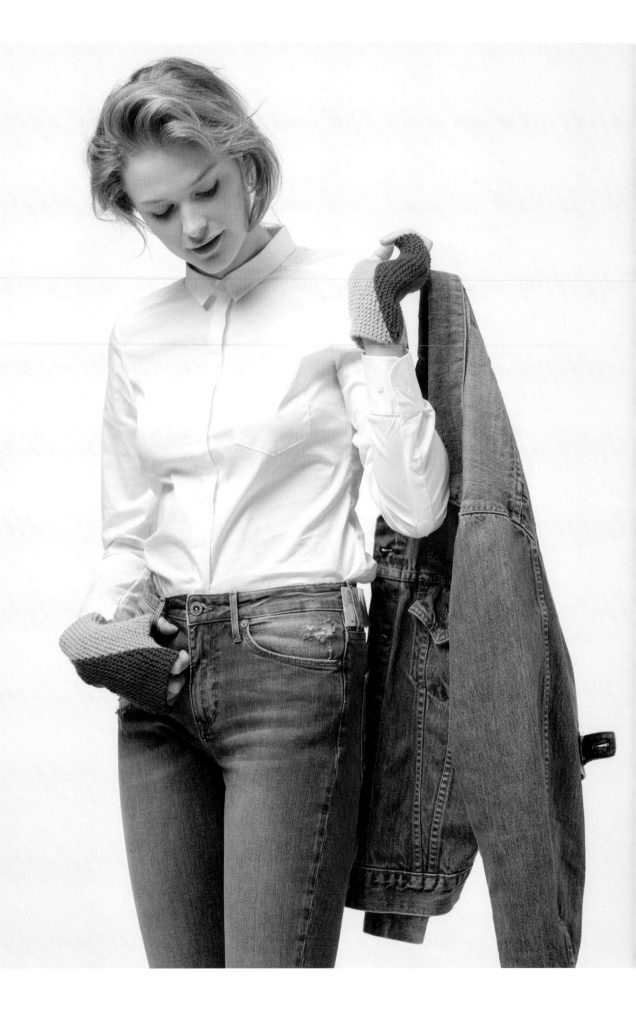

hemisect
MITTS

Cast on provisionally at the outer edge, the Hemisect Mitts are worked flat in two colors, then grafted for a seamless finish. The yarnover method makes a smooth and tidy transition between the colors.

FINISHED SIZE
S/M [M/L]; about 7 [7¾]" [18 [19.5] cm] hand circumference and 6¼ [7]" [16 [18] cm] length, measured unstretched. Mitts shown measure 6¼" [16 cm].

YARN
Worsted weight [#4 Medium].

Shown here: Cascade Yarns 220 Superwash (100% superwash wool; 220 yd [200 m]/3½ oz [100 g]): #882 Plum Crazy [MC], 1 ball; #877 Golden [CC], 1 ball.

NEEDLES
Size U.S. 6 [4 mm]. *Adjust needle size if necessary to obtain the correct gauge.*

NOTIONS
1 stitch marker [m]; yarn needle; scrap yarn for provisional CO.

GAUGE
21 sts and 42 rows = 4" [10 cm] in garter st.

Notes

When working to 2 sts before previous turning point, do not count the yarnover as a stitch.

To prevent gaps, be sure to keep the backward yarnover snug when working the stitch that follows it; also work the first row snugly after completing the thumb.

FIRST SIDE OF HAND

Using invisible provisional method (see Techniques) and MC, CO 33 (37) sts.

Knit 1 RS row.

SET-UP SHORT-ROW 1: (WS) Knit to last 2 sts, turn.

SET-UP SHORT-ROW 2: (RS) Yo, knit to end.

SHORT-ROW 1: Knit to 2 sts before previous turning point, turn.

SHORT-ROW 2: Yo, knit to end.

Rep Short-rows 1 and 2 fourteen (sixteen) more times until 1 st is left to knit to end.

NEXT ROW: (WS) Knit to yo, *sl yo to right needle correcting stitch mount, return yo to left needle, k2tog, k1; rep from * to end; cut MC yarn.

SET-UP SHORT-ROW 1: (RS) With CC, k2, turn.

SET-UP SHORT-ROW 2: (WS) Yo, knit to end.

SHORT-ROW 1: Knit to yo, sl yo to right needle correcting stitch mount, return yo to left needle, k2tog, k1, turn.

SHORT-ROW 2: Yo, knit to end.

Rep Short-rows 1 and 2 fourteen (sixteen) more times until all but the last st have been worked.

NEXT ROW: (RS) Knit to yo, sl yo to right needle correcting stitch mount, return yo to left needle, k2tog, ending at top edge.

THUMB

SET-UP SHORT-ROW 1: (WS) K10, place marker, k2, turn.

SET-UP SHORT-ROW 2: (RS) Yo, knit to m, turn.

SHORT-ROW 1: Knit to yo, sl yo to right needle correcting stitch mount, return yo to left needle, k2tog, k1, turn.

SHORT-ROW 2: Yo, knit to m, turn.

Rep Short-rows 1 and 2 four more times until 12 sts have been worked for thumb length.

NEXT ROW: (WS) Knit to yo, sl yo to right needle correcting stitch mount, return yo to left needle, k2tog, knit to end at bottom cuff edge.

NEXT ROW: Knit to m, turn.

SET-UP SHORT-ROW 1: (WS) K12, turn.

SET-UP SHORT-ROW 2: (RS) Yo, knit to m, turn.

SHORT-ROW 1: Knit to 2 sts before previous turning point, turn.

SHORT-ROW 2: Yo, knit to m, turn.

Rep Short-rows 1 and 2 four more times; on last row removing marker and knitting to end at top edge.

NEXT ROW: (WS) Knit to yo, *sl yo to right needle correcting stitch mount, return yo to left needle, k2tog, k1; rep from * 5 more times, knit to end at bottom cuff edge.

SECOND SIDE OF HAND

SET-UP SHORT-ROW 1: (RS) Knit to last 2 sts, turn.

SET-UP SHORT-ROW 2: (WS) Yo, knit to end.

SHORT-ROW 1: Knit to 2 sts before previous turning point, turn.

SHORT-ROW 2: Yo, knit to end.

Rep Short-rows 1 and 2 fourteen (sixteen) more times until 1 st is left to knit to end. Cut CC yarn.

NEXT ROW: (RS) With MC, knit to yo, *sl yo to right needle correcting stitch mount, return yo to left needle, k2tog, k1; rep from * to end at top edge.

SET-UP SHORT-ROW 1: (WS) K2, turn.

SET-UP SHORT-ROW 2: (RS) Yo, knit to end.

SHORT-ROW 1: Knit to yo, sl yo to right needle correcting stitch mount, return yo to left needle, k2tog, k1, turn.

SHORT-ROW 2: Yo, knit to end.

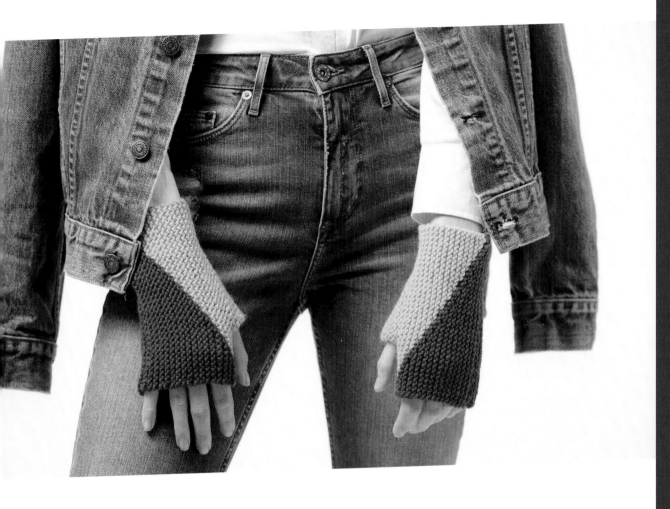

Rep Short-rows 1 and 2 fourteen (sixteen) more times until all but the last st have been worked.

NEXT ROW: (WS) Knit to yo, sl yo to right needle correcting stitch mount, return yo to left needle, k2tog, ending at bottom cuff edge.

Cut yarn, leaving live sts on needle and a 20" (51 cm) tail for grafting sts.

FINISHING

Place 33 (37) provisionally CO sts on spare needle, correcting stitch mount as needed. Fold mitt with WS facing together and hold needles parallel with final row of sts in front and CO sts in back; working yarn is coming from right end of front needle. Graft all sts using yarn tail and garter method, as follows:

SET-UP: Insert needle through first st on front needle purlwise, then through first st on back needle purlwise.

FRONT NEEDLE: Insert needle through first st knitwise and drop st off needle, then through next st purlwise, leaving st on needle.

BACK NEEDLE: Insert needle through first st knitwise and drop st off needle, then through next st purlwise, leaving st on needle.

Rep Front and Back needle steps until all sts are grafted.

Weave in ends and block lightly.

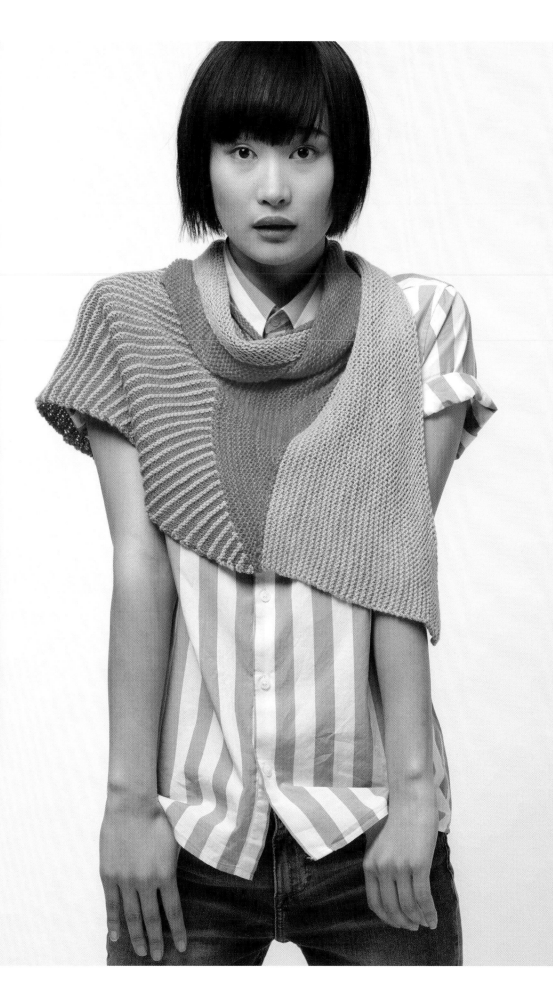

trichotomy
SHAWL

Three short-row wedges worked using the yarnover method are joined seamlessly into a tri-patterned shawl.

FINISHED SIZE
About 56" [142 cm] wide and 24" [61 cm] deep.

YARN
Fingering weight [#1 Super Fine].

Shown here: Baah Yarn La Jolla [100% merino wool; 400 yd [366 m]/3½ oz [100 g]]: California Poppy (MC), 1 skein; Grey Onyx (CC), 1 skein.

NEEDLES
Size U.S. 6 [4mm]: 24" [60 cm] circular (cir). *Adjust needle size if necessary to obtain the correct gauge.*

NOTIONS
Yarn needle.

GAUGE
15 sts and 30 rows = 4" [10 cm] in garter st.

NOTES
When working to a certain number of sts before previous turning point, do not count the yarnover as a stitch. To prevent gaps, be sure to keep the backward yarnover snug when working the following stitch.

Circular needle is used to accommodate large number of sts. Do not join; work back and forth in rows.

STRIPE WEDGE

Using long-tail method and MC, CO 81 sts.

Knit 1 WS row.

SET-UP SHORT-ROW 1: (RS) Knit to last st, turn.

SET-UP SHORT-ROW 2: (WS) Yo, purl to end.

Do not cut the yarns between color changes; carry the unused color up at the edge of the piece.

SHORT-ROW 1: With CC, knit to 1 st before previous turning point, turn.

SHORT-ROW 2: Yo, knit to end.

SHORT-ROW 3: With MC, knit to 1 st before previous turning point, turn.

SHORT-ROW 4: Yo, purl to end.

Rep Short-rows 1–4 until all sts have been worked, ending with CC. Cut CC yarn.

NEXT ROW: (RS) Cont with MC only, k1, *sl yo to right needle correcting stitch mount, return yo to left needle, k2tog; rep from * to end—81 sts.

MC GARTER WEDGE

SET-UP SHORT-ROW 1: (WS) Using working MC, knit to last st, turn.

SET-UP SHORT-ROW 2: (RS) Yo, knit to end, k1f&b—1 st inc'd.

SHORT-ROW 1: Knit to 2 sts before previous turning point, turn.

SHORT-ROW 2: Yo, knit to end, k1f&b—1 st inc'd.

Rep Short-rows 1 and 2 until 2 sts rem before last turning point.

NEXT ROW: (WS) K1, *k1, sl yo to right needle correcting stitch mount, return yo to left needle, k2tog; rep from * to end—161 sts. Cut MC yarn.

CC GARTER WEDGE

SET-UP SHORT-ROW 1: (RS) With CC and beg where MC ended, knit to last st, turn.

SET-UP SHORT-ROW 2: (WS) Yo, knit to end.

SHORT-ROW 1: Knit to 4 sts before previous turning point, turn.

SHORT-ROW 2: Yo, knit to end.

Rep Short-rows 1 and 2 until 4 sts rem before last turning point.

NEXT ROW: (RS) K1, *k3, sl yo to right needle correcting stitch mount, return yo to left needle, k2tog; rep from * to end—161 sts.

FINISHING

BO all sts loosely knitwise on WS. Weave in ends and block.

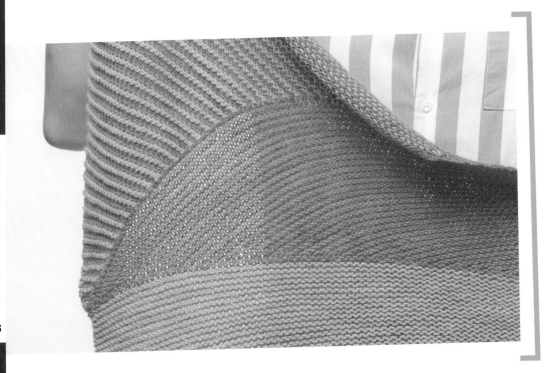

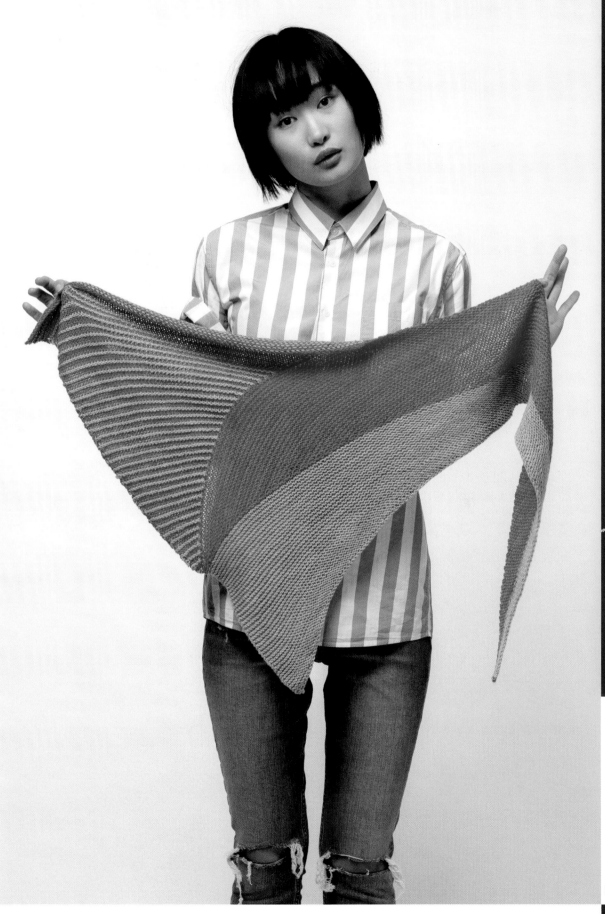

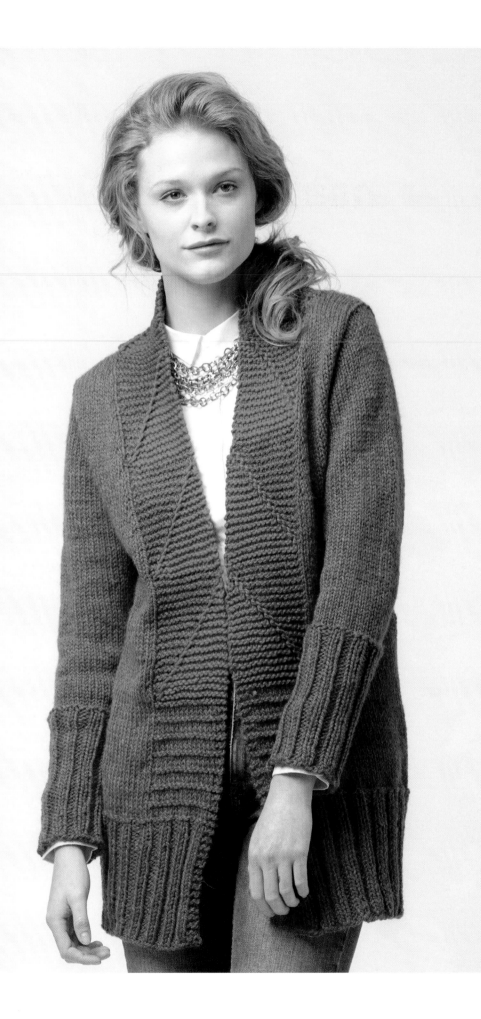

[meeting triangles]
SWEATER COAT

Short-row triangles created with the
yarnover method meet to make squares
along the collar panel of this sweater coat.
The collar is worked seamlessly along with
the body; additional short-rows shape
the shoulders and the sleeve caps.

FINISHED SIZE
About 35¾ [40, 44, 48, 51¾]" [91
[101.5, 112, 122, 131.5] cm] bust
circumference. Garment shown
measures 40" [101.5 cm].

YARN
Chunky weight [#5 Bulky]

Shown here: Cascade Yarns Eco +
[100% wool; 478 yd [437 m]/8.82
oz [250 g]]: Pumpkin Spice [MC],
2 [2, 3, 3, 3] skeins; Real Teal [CC],
about 50–60 yd.

NEEDLES
Size U.S. 9 [5.5 mm]: 32" [80 cm]
circular [cir]. *Adjust needle size if
necessary to obtain the correct
gauge.*

NOTIONS
4 stitch markers [m]; 2 removable
markers; stitch holders; yarn
needle; scrap yarn for provisional
CO.

GAUGE
15 sts and 20 rows = 4" [10 cm] in
St st. One short-row triangle panel
of 15 sts and 30 rows measures
about 4" [10 cm] wide and 5½"
[14 cm] long.

Notes

Meeting Triangles is worked seamlessly from the top down, with the triangles along the front and collar created using short-rows simultaneously with the body. The cardigan is designed to be worn open, displaying the colorwork on the front edges.

Stitch Guide

GARTER STRIPE

ROW 1: (RS) Knit.

ROW 2: (WS) Knit to Right Collar m, sl m, purl to Left Collar m, sl m, knit to end.

ROW 3: Knit.

ROW 4: K2, purl to last 2 sts, k2.

K2, P2 RIB (worked flat, multiple of 4 sts + 2)

ROW 1: (RS) *K2, p2; rep from * to last 2 sts, k2.

ROW 2: (WS) *P2, k2; rep from * to last 2 sts, p2.

Rep Rows 1 and 2 for patt.

K2, P2 RIB (worked in the rnd, multiple of 4 sts)

RND 1: *K2, p2; rep from * to end.

Rep Rnd 1 for patt.

BACK

Using cable method (see Techniques) and MC, CO 52 (56, 57, 60, 62) sts.

Knit 1 RS row.

SET-UP ROW: (WS) P8 (9, 9, 10, 10), place removable m in last st worked, p36 (38, 39, 40, 42), place removable m in last st worked, purl to end—8 (9, 9, 10, 10) sts outside of each marked st.

Shape Back Neck

SHORT-ROW 1: (RS) Knit to second marked st, k1, turn.

SHORT-ROW 2: (WS) Yo, purl to second marked st, p1, turn.

SHORT-ROW 3: Yo, knit to yo, sl yo to right needle correcting stitch mount, return st to left needle, k2tog, k3 (3, 3, 4, 4), turn.

SHORT-ROW 4: Yo, purl to yo, sl yo to right needle correcting stitch mount, return st to left needle, p2tog, p3 (3, 3, 4, 4), turn.

ROW 5: Yo, knit to yo, sl yo to right needle correcting stitch mount, return st to left needle, k2tog, knit to end.

NEXT ROW: Purl to yo, sl yo to right needle correcting stitch mount, return st to left needle, p2tog, purl to end.

Work 28 (28, 28, 26, 26) more rows in St st for upper back, ending with a WS row.

Shape Armhole

INC ROW: (RS) K1, M1R, knit to last st, M1L, k1—2 sts inc'd.

Rep Inc row every RS row 1 (2, 4, 6, 8) more time(s), ending with a WS row—56 (62, 67, 74, 80) sts.

Cut yarn and place sts on holder.

Right Collar

Using invisible provisional method (see Techniques) and MC, CO 16 sts, leaving a 36" (91.5 cm) yarn tail.

Right Back MC Collar Triangle (30 rows)

ROW 1: (RS) Knit to end.

ROW 2: (WS) Knit to end.

SET-UP SHORT-ROW 1: (RS) Knit to last st, turn.

SET-UP SHORT-ROW 2: (WS) Yo, knit to end.

SHORT-ROW 1: (RS) Knit to 1 st before previous turning point, turn.

SHORT-ROW 2: (WS) Yo, knit to end.

Rep Short-rows 1 and 2 twelve more times, ending with a WS row, until 2 sts rem unworked.

Cut MC yarn and turn work. Work Right Back CC Collar Triangle as follows:

Right Back CC Collar Triangle [30 rows]

NEXT ROW: (RS) With CC, k2, [sl yo to right needle correcting stitch mount, return st to left needle, k2tog] to end.

SET-UP SHORT-ROW 1: (WS) K1, turn.

SET-UP SHORT-ROW 2: (RS) Yo, k1.

SHORT-ROW 1: Knit to yo, sl yo to right needle correcting stitch mount, return st to left needle, k2tog, turn.

SHORT-ROW 2: Yo, knit to end.

Rep Short-rows 1 and 2 twelve more times, until 2 sts rem unworked.

NEXT ROW: (WS) Knit to yo, sl yo to right needle correcting stitch mount, return st to left needle, k2tog, k1. Cut CC yarn.

RIGHT FRONT SHOULDER

With RS facing, rotate Back so that CO edge is at top. Using MC, beg at right shoulder edge and ending at first removable m, pick up and knit 8 (9, 9, 10, 10) sts from CO edge for Right Shoulder;

with RS facing, knit first st of Right Collar, pass last st of Right Shoulder over this st, pm, knit to end of Right Collar sts—23 (24, 24, 25, 25) sts; 15 Collar sts and 8 (9, 9, 10, 10) Right Front sts.

NEXT ROW: (WS) Knit to m, sl m, purl to end.

Collar panel now consists of 15 sts. Work 15 collar sts in Right Front Collar Triangle patt, alternating MC and CC triangles [instructions appear on the following page]; AT THE SAME TIME, shape right neck and armhole as follows:

Shape Right Neck

NOTE: Neck shaping will continue past armhole shaping and joining of fronts and back.

INC ROW: (RS) Knit to 1 st before m, M1L, k1, sl m, work Right Front Collar sts in patt as established, beg with Set-up short-row 1 of MC Triangle to end—1 st inc'd.

NEXT ROW: (WS) Work Right Collar sts in patt as established, sl m, purl to end.

Rep Inc row every 8 rows twice more, then every 4 rows 7 (8, 9, 10, 10) times—10 (11, 12, 13, 13) sts inc'd; AT THE SAME TIME, when piece

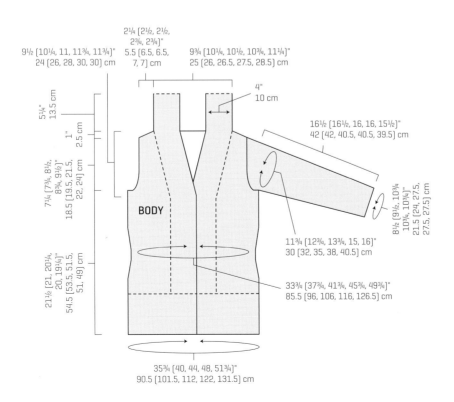

measures 32 (32, 32, 30, 30) rows in MC from shoulder CO edge, shape armhole as follows:.

Shape Armhole

INC ROW: (RS) K1, M1R, work in patt as established to end—1 st inc'd.

Rep Inc row every RS row 1 (2, 4, 6, 8) more times, ending with a WS row—32 (34, 37, 41, 44) sts; 15 Collar sts and 17 (19, 22, 26, 29) Right Front sts.

Cut yarn and place sts on holder.

Working Short-row Collar Triangles, when Right and Left Fronts worked separately:

RIGHT FRONT COLLAR MC TRIANGLE [30 ROWS]

ROW 1: (RS) With MC, knit to end.

ROW 2: (WS) Knit to m, sl m, purl to end.

SET-UP SHORT-ROW 1: (RS) Knit to last st, turn.

SET-UP SHORT-ROW 2: (WS) Yo, knit to m, sl m, purl to end.

SHORT-ROW 1: (RS) Knit to 1 st before previous turning point, turn.

SHORT-ROW 2: (WS) Yo, knit to m, sl m, purl to end.

Rep Short-rows 1 and 2 twelve more times, ending with a WS row, until 1 st rem unworked.

NEXT ROW: (RS) Knit to m; drop (do not cut) MC yarn. With CC, work CC Triangle on Right Collar as follows:

RIGHT FRONT COLLAR CC TRIANGLE [30 ROWS]

ROW 1: (RS) With CC, k1, *sl yo to right needle correcting stitch mount, return st to left needle, k2tog; rep from * to end.

SET-UP SHORT-ROW 1: (WS) K1, turn.

SET-UP SHORT-ROW 2: (RS) Yo, k1.

SHORT-ROW 1: (WS) Knit to yo, sl yo to right needle correcting stitch mount, return st to left needle, k2tog, turn.

SHORT-ROW 2: (RS) Yo, knit to end.

Rep Short-rows 1 and 2 twelve more times, until 1 st rem unworked.

NEXT ROW: (WS) Knit to yo, sl yo to right needle correcting stitch mount, return st to left needle, k2tog.

NEXT ROW: (RS) Knit to yo, sl yo to right needle correcting stitch mount, return st to left needle, k2tog; cut CC yarn; resume with MC yarn and Row 1 of Right MC Triangle, above.

Left Collar

Using invisible provisional method and MC, CO 16 sts.

LEFT BACK MC TRIANGLE [30 ROWS]

ROW 1: (RS) Knit to end.

SET-UP SHORT-ROW 1: (WS) Knit to last st, turn.

SET-UP SHORT-ROW 2: (RS) Yo, knit to end.

SHORT-ROW 1: (WS) Knit to 1 st before previous turning point, turn.

SHORT-ROW 2: (RS) Yo, knit to end.

Rep Short-rows 1 and 2 twelve more times, ending with a RS row, until 2 sts rem unworked.

NEXT ROW: (WS) K2, *sl yo to right needle correcting stitch mount, return st to left needle, k2tog; rep from * to end.

Cut MC yarn and turn. Join CC and work CC Triangle on Left Back Collar as follows:

LEFT BACK CC TRIANGLE [30 ROWS]

SET-UP SHORT-ROW 1: (RS) With CC, k1, turn.

SET-UP SHORT-ROW 2: (WS) Yo, knit to end.

SHORT-ROW 1: Knit to yo, sl yo to right needle correcting stitch mount, return st to left needle, k2tog, turn.

SHORT-ROW 2: Yo, knit to end.

Rep Short-rows 1 and 2 twelve more times, until 2 sts rem unworked.

NEXT ROW: (RS) Knit to yo, sl yo to right needle correcting stitch mount, return st to left needle, k2tog, k1, turn.

NEXT ROW: (WS) Knit to end.

Turn work, cut CC yarn.

LEFT FRONT SHOULDER

With RS facing and MC, knit to last st of Left Collar, pm, sl 1; with RS facing and with CO edge of

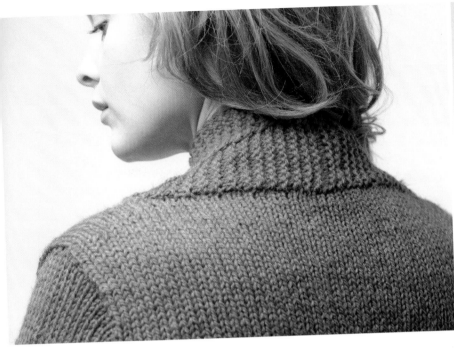

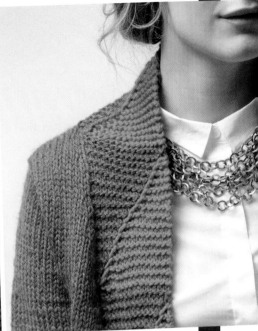

Back at top, beg after marked st at left neck edge, pick up and knit 1 st, pass slipped st on right needle over this st, then pick up and knit 7 (8, 8, 9, 9) sts from CO edge for left shoulder—23 (24, 24, 25, 25) sts; 15 collar sts and 8 (9, 9, 10, 10) Left Front sts.

NEXT ROW: (WS) Purl to m, sl m, knit to last st, turn.

Collar panel now consists of 15 sts. Work 15 collar sts in Left Front Collar Triangle patt, alternating MC and CC triangles [instructions appear on the following pages]; AT THE SAME TIME, shape left neck and armhole as follows:

Shape Left Neck

NOTE: Neck shaping will continue past armhole shaping and joining of fronts and back.

INC ROW: (RS) Work Left Front Collar sts in patt as established, beg with Set-up short-row 2 of MC Triangle to m, sl m, k1, M1R, knit to end—1 st inc'd.

NEXT ROW: (WS) Purl to m, sl m, work Left Collar sts in patt as established.

Rep Inc row every 8 rows twice more, then every 4 rows 7 (8, 9, 10, 10) times—10 (11, 12, 13, 13) sts inc'd. AT THE SAME TIME, when piece measures 32 (32, 32, 30, 30) rows in MC from CO edge, shape armhole as follows:

Shape Armhole

INC ROW: (RS) Work in patt as established to last st, M1L, k1—1 st inc'd.

Rep Inc row every RS row 1 (2, 4, 6, 8) more time(s), ending with a WS row—32 (34, 37, 41, 44) sts; 15 Collar sts and 17 (19, 22, 26, 29) Left Front sts.

Working Short-row Collar Triangles, when Right & Left Fronts worked separately:

LEFT FRONT COLLAR MC TRIANGLE [30 ROWS]

NEXT ROW: (RS) With MC, knit to m, sl m, sl yo to right needle correcting stitch mount, return st to left needle, k2tog, cont in patt to end.

SET-UP SHORT-ROW 1: (WS) Purl to m, sl m, knit to last st, turn.

SET-UP SHORT-ROW 2: (RS) Yo, knit to end.

SHORT-ROW 1: (WS) Purl to m, sl m, knit to 1 st before previous turning point, turn.

SHORT-ROW 2: (RS) Yo, knit to end.

Rep Short-rows 1 and 2 twelve more times, ending with a RS row, until 1 st rem unworked.

NEXT ROW: (WS) Purl to m, sl m, k1, *sl yo to right needle correcting stitch mount, return st to left needle, k2tog; rep from * to end. Cut MC yarn and turn work.

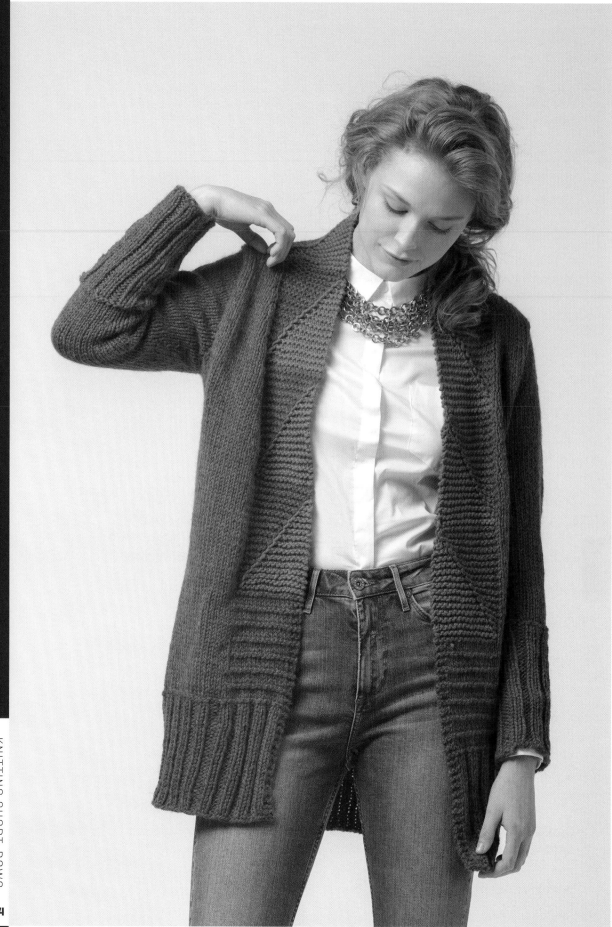

Join CC and work CC Triangle on Left Collar as follows:

LEFT FRONT COLLAR CC TRIANGLE (30 ROWS)

SET-UP SHORT-ROW 1: (RS) With CC, k1, turn.

SET-UP SHORT-ROW 2: (WS) Yo, knit to end.

SHORT-ROW 1: Knit to yo, sl yo to right needle correcting stitch mount, return st to left needle, k2tog, turn.

SHORT-ROW 2: Yo, knit to end.

Rep Short-rows 1 and 2 twelve more times, until 1 st rem unworked.

NEXT ROW: (RS) Knit to yo, sl yo to right needle correcting stitch mount, return st to left needle, k2tog, turn.

NEXT ROW: (WS) Sl m to left needle, yo, sl m back to right needle, knit to end.

Cut CC yarn.

JOIN FRONTS AND BACK

NEXT ROW: (RS) Work Left Front sts in patt as established, CO 4 (6, 8, 8, 10) sts using backward-loop method and pm after first 2 (3, 4, 4, 5) sts for left side seam, knit 56 (62, 67, 74, 80) back sts from holder, CO 4 (6, 8, 8, 10) sts and pm after first 2 (3, 4, 4, 5) sts for right side seam, work Right Front sts from holder in patt as established—128 (144, 159, 174, 190) sts.

Work in patt as established, continuing neck edge increases as established—134 (150, 165, 180, 194) sts after neck shaping is complete.

Working Short-row Collar Triangles, after Right & Left Fronts are joined with Back:

LEFT & RIGHT MC TRIANGLE (30 ROWS)

NEXT ROW: (RS) Knit to Left Collar m, sl m, sl yo to right needle correcting stitch mount, return st to left needle, k2tog, knit to end.

SET-UP SHORT-ROW 1: (WS) Knit to Right Collar m, sl m, purl to Left Collar m, sl m, knit to last st, turn.

SET-UP SHORT-ROW 2: (RS) Yo, knit to Right Collar m, sl m, knit to last st, turn.

SHORT-ROW 1: (WS) Yo, knit to Right Collar m, sl m, purl to Left Collar m, sl m, knit to 1 st before previous turning point, turn.

SHORT-ROW 2: (RS) Yo, knit to Right Collar m, sl m, knit to 1 st before previous turning point, turn.

Rep Short-rows 1 and 2 twelve more times, ending with a RS row, until 1 st rem unworked on both Left and Right Collars; turn work, yo, k1. Drop MC yarn, but do not cut and do not turn. Work CC Triangle on Right Collar as follows

RIGHT CC TRIANGLE (30 ROWS)

NEXT ROW: (RS) With CC, k1, *sl yo to right needle correcting stitch mount, return st to left needle, k2tog; rep from * to end.

SET-UP SHORT-ROW 1: (WS) K1, turn.

SET-UP SHORT-ROW 2: (RS) Yo, k1.

SHORT-ROW 1: Knit to yo, sl yo to right needle correcting stitch mount, return st to left needle, k2tog, turn.

SHORT-ROW 2: Yo, knit to end.

Rep Short-rows 1 and 2 twelve more times, until 1 st rem unworked.

NEXT ROW: (WS) Knit to yo, sl yo to right needle correcting stitch mount, return st to left needle, k2tog. Cut CC yarn. With attached MC yarn, purl to Left Collar m, k1, *sl yo to right needle correcting stitch mount, return st to left needle, k2tog; rep from * to end. Cut MC yarn and turn work.

Join CC and work CC Triangle on Left Collar as follows:

LEFT CC TRIANGLE (30 ROWS)

SET-UP SHORT-ROW 1: (RS) K1, turn.

SET-UP SHORT-ROW 2: (WS) Yo, knit to end.

SHORT-ROW 1: Knit to yo, sl yo to right needle correcting stitch mount, return st to left needle, k2tog, turn.

SHORT-ROW 2: Yo, knit to end.

Rep Short-rows 1 and 2 twelve more times, until 1 st rem unworked.

NEXT ROW: (RS) Knit to yo, sl yo to right needle correcting stitch mount, return st to left needle, k2tog.

NEXT ROW: (WS) Sl m to left needle, yo, sl m back to right needle, knit to end.

Cut CC yarn.

AT THE SAME TIME, when body measures 6" (15 cm) from underarm, shape Body between Left and Right Collar m as follows:

DEC ROW: (RS) [Knit to 3 sts before next side seam m, ssk, k1, sl m, k1, k2tog] twice, knit to Right Collar m—4 sts dec'd.

Rep Dec row every 10th row once more—126 (142, 157, 172, 186) sts rem.

Work 9 rows even.

INC ROW: (RS) [Knit to 1 st before next side seam m, M1R, k1, sl m, k1, M1L] twice, knit to Right Collar m—4 sts inc'd.

Rep Inc row every 10th row once more—134 (150, 165, 180, 194) sts.

Discontinue Short-row Collar Triangles after 3 complete sets have been worked on the Fronts, excluding the Back Collar Triangles, and continue with Garter Stripe patt instead as follows:

NEXT ROW: (RS) Knit to Left Collar m, sl m, sl yo to right needle correcting stitch mount, return st to left needle, k2tog, knit to end.

Beg with Row 2, work in Garter Stripe patt over the 15 Collar sts each side for 28 rows.

Hem

Knit 2 rows, decreasing 0 (0, 1, 1, 0) st(s) at each side seam and 0 (0, 1, 0, 0) st(s) at center back on last row—134 (150, 162, 178, 194) sts rem.

Beg with a RS row, work in K2, P2 Rib worked flat for 30 rows (6" [15 cm]).

Bind off all sts in patt.

SLEEVES

With RS facing and MC, beg at center bottom of armhole, pick up and knit 2 (3, 4, 4, 5) sts from CO sts of underarm, 20 (21, 22, 24, 25) sts evenly spaced around armhole to shoulder, 20 (21, 22, 24, 25) sts evenly spaced around armhole to beg of underarm, and 2 (3, 4, 4, 5) sts from CO

sts of underarm, pm and join for working in the rnd—44 (48, 52, 56, 60) sts.

Shape Sleeve Cap

SET-UP SHORT-ROW 1: (RS) K29 (32, 34, 37, 40), turn.

SET-UP SHORT-ROW 2: (WS) Yo, p14 (16, 16, 18, 20), turn.

SHORT-ROW 1: Yo, knit to yo, sl yo to right needle correcting stitch mount, return st to left needle, k2tog, turn.

SHORT-ROW 2: Yo, purl to yo, sl yo to right needle correcting stitch mount, return st to left needle, p2tog, turn.

Rep Short-rows 1 and 2 thirteen (fourteen, sixteen, seventeen, eighteen) more times, until 1 st rem unworked on each side of m.

NEXT RND: (RS) Yo, knit to yo, sl yo to right needle correcting stitch mount, return st to left needle, k2tog, sl m, ssk first st of rnd tog with following yo.

Knit 6 (6, 5, 3, 2) rnds.

DEC RND: K1, ssk, knit to 3 sts before m, k2tog, k1—2 st dec'd.

Rep Dec rnd every 7 (7, 6, 4, 3) rnds 5 (5, 2, 0, 2) more times, then every 8 (8, 7, 5, 4) rnds 0 (0, 3, 7, 7) times—32 (36, 40, 40, 40) sts rem.

Knit 5 rnds, or to desired length before cuff.

Purl 1 rnd.

Cuff

Work 35 rnds (7" [18 cm]) in K2, P2 Rib worked in the rnd.

Bind off all sts in patt.

FINISHING
Collar

Place the 16 provisionally CO sts of Right Collar on needle, correcting stitch mount as needed.

Both live RS rows of the collars are knit rows, so a set-up step is required to ensure a seamless graft.

SET-UP ROW: (RS) Using yarn tail, purl 1 row.

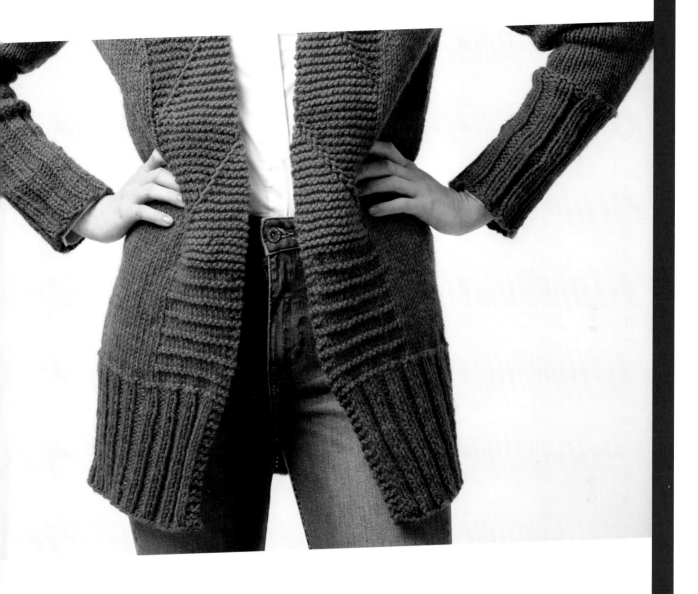

Place the 16 provisionally CO sts of Left Collar on needle, correcting stitch mount as needed.

Hold collar panels with WS facing tog and needles parallel with Left Collar in front and Right Collar in back; graft all sts using same yarn tail and reverse-garter method as follows:

SET-UP: Insert needle through first st on front needle knitwise, then through first st on back needle knitwise.

FRONT NEEDLE: Insert needle through first st purl-wise and drop st off needle, then through next st knitwise, leaving st on needle.

BACK NEEDLE: Insert needle through first st purl-wise and drop st off needle, then through next st knitwise, leaving st on needle.

Rep Front and Back Needle steps until all sts are grafted.

Weave in ends, except long yarn tail near collar and back neck. Using yarn tail, sew Left Collar to back neck edge from center back neck to shoulder. With new yarn, sew rem Right Collar to back neck edge.

Weave in rem ends and block.

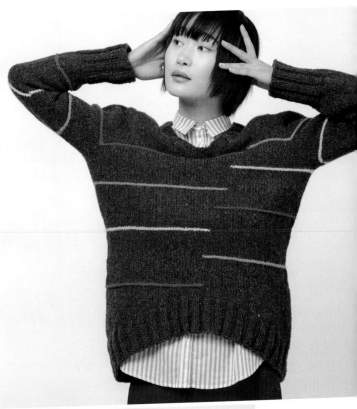

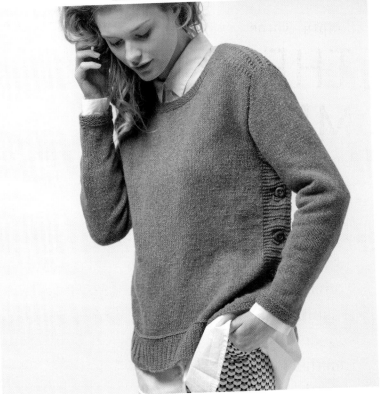

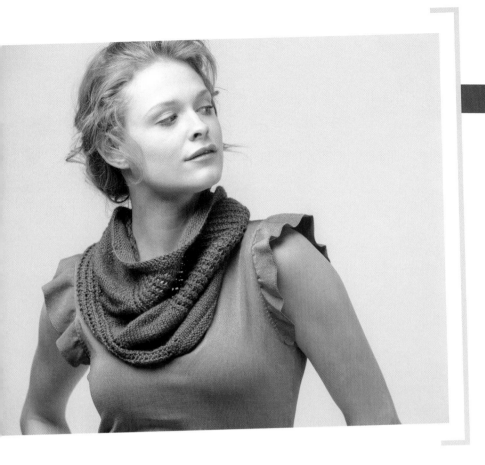

Chapter Three

THE GERMAN METHOD

The German method is easy to work back and forth in stockinette, garter, and reverse stockinette and yields tidy results. In the German method, stitches are worked to the desired turning point, the work is turned, then a yarnover is used to pull up a stitch from the row below, resulting in both of its legs creating a double stitch on the needle. On a subsequent row, both legs of the stitch are worked together to disguise the turning point. This book uses the abbreviation "DS" as the instruction to create a double stitch.

figure 1

figure 2

figure 3

figure 4

figure 5

THE GERMAN METHOD ON A KNIT ROW

1 Knit to the turning point and turn the work (Figure 1).

2 Slip the next stitch purlwise (**Figure 2**).

3 Bring the working yarn to the back over the right needle and pull upward so that both legs of the stitch below the slipped stitch are pulled up onto the needle, creating what appears to be an odd-looking double stitch (Figure 3).

4 If you're working in stockinette stitch, bring the working yarn to the front again between the needles (**Figure 4**); purl the next row (**Figure 5**). If you're working in garter stitch, the yarn is already at the back; knit the next row.

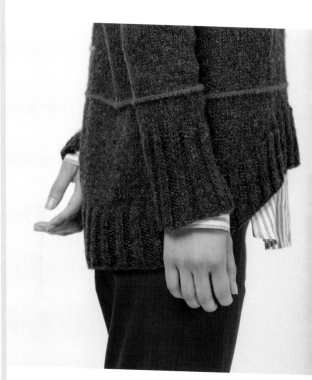

THE GERMAN METHOD ON A PURL ROW

1 Purl to the turning point and turn the work (Figure 1).

2 Bring the working yarn to the front between the needles (Figure 2).

3 Slip the next stitch purlwise (**Figure 3**).

4 Bring the working yarn to the back over the right needle and pull upward so that both legs of the stitch below are pulled up onto the needle, creating what appears to be a double stitch (**Figure 4**); knit the next row (Figure 5).

The stitch appears double because both legs are around the front of the needle, making it very obvious to spot; on a subsequent row, work both legs together to disguise the turning point.

figure 1

figure 2

figure 3

figure 4

figure 5

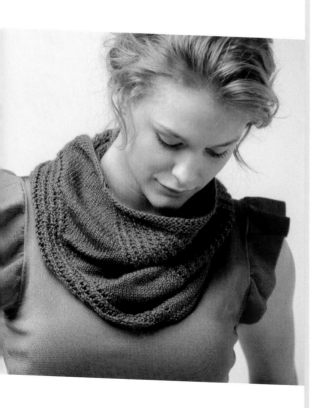

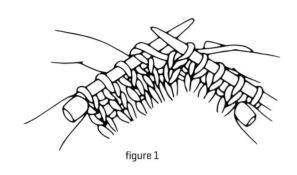

figure 1

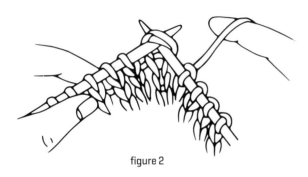

figure 2

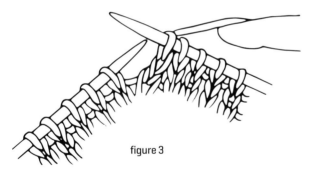

figure 3

TO WORK THE DOUBLE STITCH ON A KNIT ROW

1 Knit to the double stitch (**Figure 1**).

2 Insert the right needle tip knitwise under both of its front legs (**Figure 2**).

3 Knit both legs together as one (**Figure 3**).

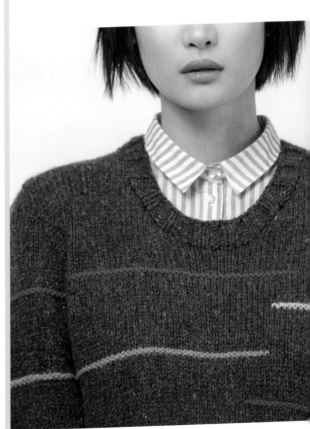

TO WORK THE DOUBLE STITCH ON A PURL ROW

1 Purl to the double stitch (**Figure 1**).

2 Insert the right needle tip purlwise under both of its front legs (**Figure 2**).

3 Purl both legs together as one (**Figure 3**).

The German method is simple and effective in stockinette stitch, reverse stockinette, and garter worked back and forth. The double stitch itself is extremely easy both to work and to see when it's time to work both legs together; just be alert and count it as only one stitch when working your pattern.

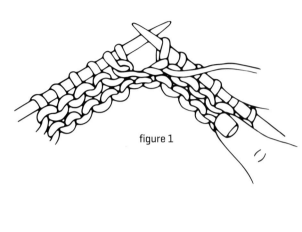

figure 1

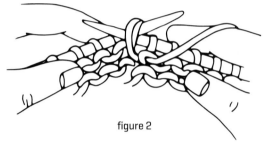

figure 2

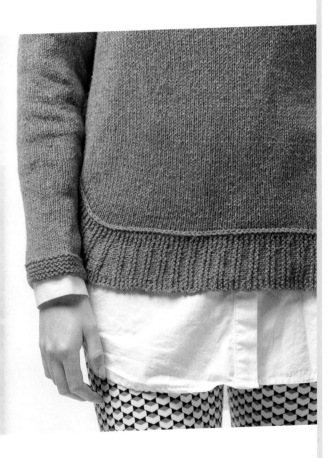

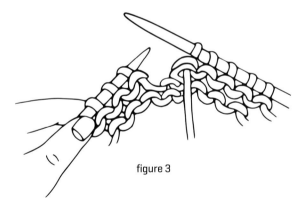

figure 3

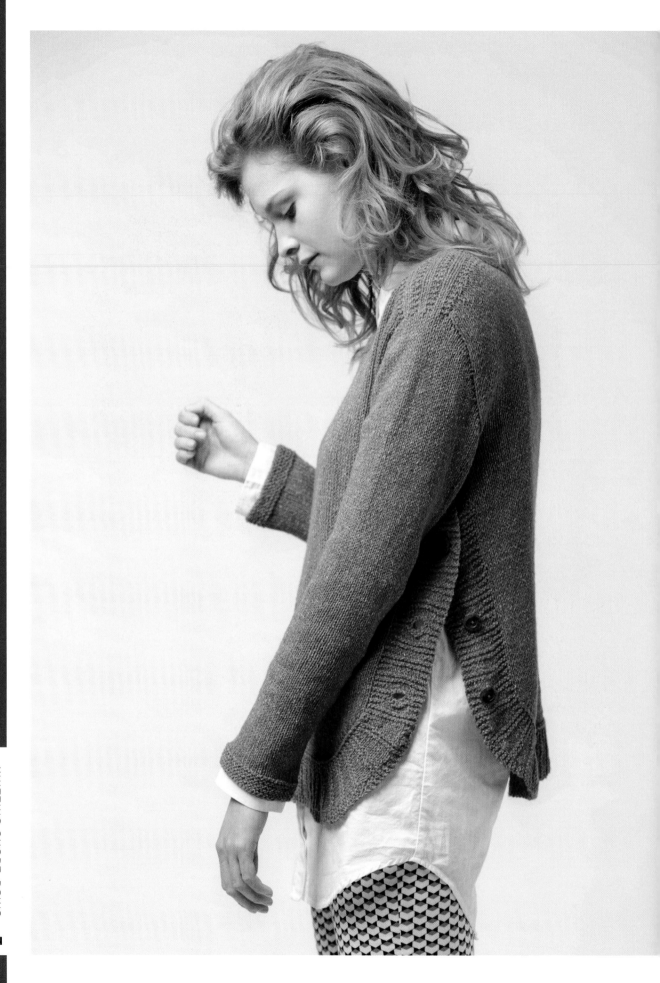

SPECIAL CONSIDERATIONS

Since this method involves pulling up a stitch from the row below, there can be some resulting distortion, particularly in garter stitch, where knit and purl rows alternate. Depending on your yarn and gauge, the effect may be minimal and well worth the simplicity of using this technique; it is basically worked the same way in all situations, and the only difference is making sure that the yarn is positioned properly in front of or behind the needles to work the next stitch, before executing each step. The steps are simple to remember and to execute and the results generally very good. For these reasons, it is equally easy to work in the round.

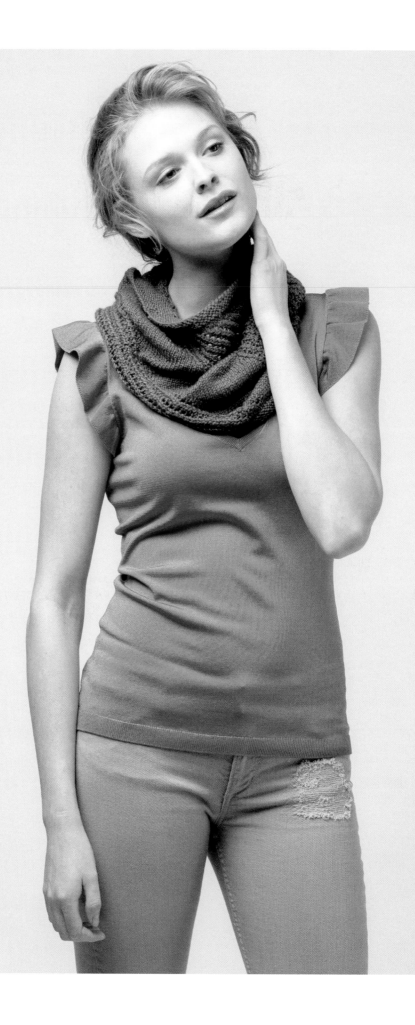

tilting lines
COWL

Subtle short-rows worked using the German method add soft depth to the ruched panel of this lacy neck warmer. The ruching is stacked to flow with the diagonal lace, adding lightness and movement.

FINISHED SIZE
About 10½" (26.5 cm) tall and 25" (63.5 cm) circumference.

YARN
Fingering weight (#1 Super Fine).

Shown here: The Fibre Company Road to China Light (65% baby alpaca, 10% cashmere, 10% camel, 15% silk; 159 yd [145 m]/1 ¾ oz [50 g]): Abalone, 2 skeins.

NEEDLES
Size U.S. 4 (3.5 mm): 16" (40 cm) circular (cir). *Adjust needle size if necessary to obtain the correct gauge.*

NOTIONS
2 stitch markers (m); yarn needle.

GAUGE
20 sts and 32 rows = 4" (10 cm) in St st; 18 sts and 47 rows = 4" (10 cm) in lace pattern.

Notes

Markers and "seams" move 1 st to the left every other round. After casting on, be sure to position the needles such that the "purl bump" side of the CO (the reverse side as you are casting on) becomes the RS; swap the positions of first and last st to lock the round, by slipping first st on right needle to left needle and pulling next st on left needle over this st and onto right needle.

Count the double loops of the stitch pulled up for the German short-row as 1 st on following rows and work both loops together as 1 st.

To prevent a bind-off that's too tight, try using a needle two sizes larger.

Stitch Guide

Double stitch (DS): On RS, move yarn to front between needles, sl 1, move yarn to back over needle; on WS, sl 1, move yarn to back over needle, move yarn to front between needles.

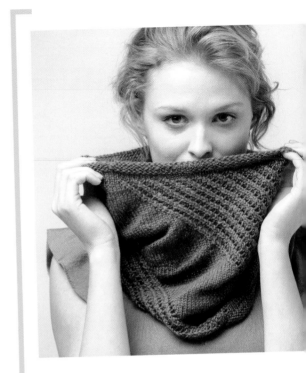

COWL

Using long-tail method, CO 120 sts; place marker (pm) and join for working in the rnd, being careful not to twist sts.

Purl 1 rnd. Knit 1 rnd.

Rep last 2 rnds twice more.

Knit 3 rnds.

SET-UP RND 1: K21, pm, [yo, ssk, k1] to end.

SET-UP RND 2: Knit.

Cowl Lace Pattern:

RND 1: Remove m, k1, replace m, knit to next m, remove m, k1, replace m, [yo, ssk, k1] to end.

RNDS 2, 4, 10, 12, AND 14: Knit.

RND 3: Rep Rnd 1.

SHORT-ROW 5: (RS) Remove m, k1, replace m, knit to 2 sts before next m, turn.

SHORT-ROW 6: (WS) DS, purl to 1 st before m, turn.

SHORT-ROW 7: DS, knit to 2 sts before previous double st, turn.

SHORT-ROW 8: DS, purl to 2 sts before previous double st, turn.

SHORT-ROW 9: DS, knit to m, remove m, k1, replace m, [yo, ssk, k1] to end.

RND 11: Rep Rnd 1.

RND 13: Rep Rnd 1.

Rep Rnds 1–14 of Cowl Lace Pattern 10 times.

Knit 4 rnds.

Purl 1 rnd. Knit 1 rnd.

Rep last 2 rnds twice more.

Bind off all sts purlwise.

FINISHING

Weave in ends and steam block lace, taking care not to flatten short-row ruching.

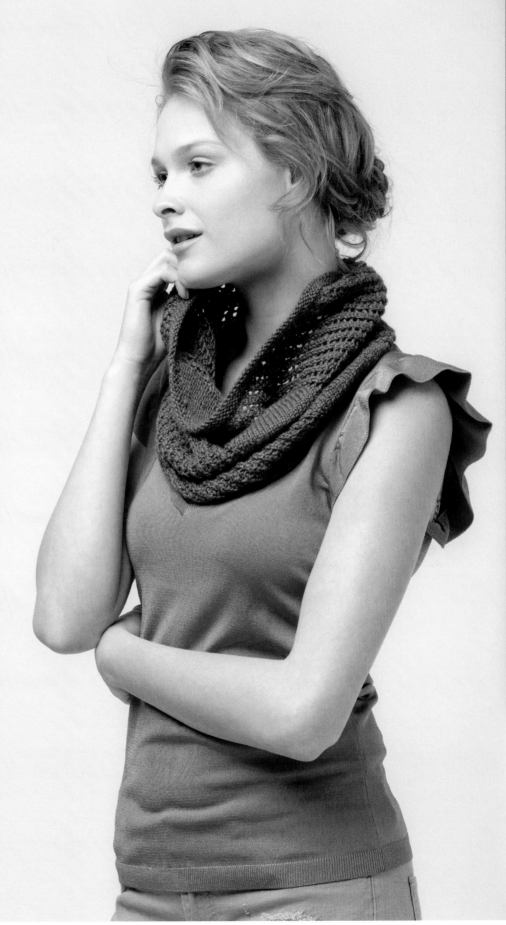

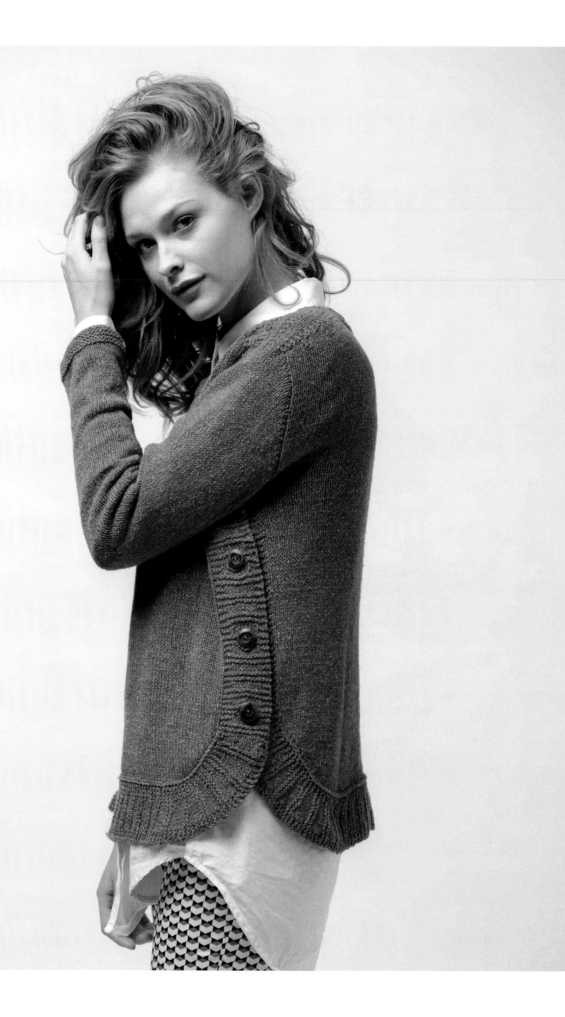

buttonside
SWEATER

Boxy and swingy, Buttonside uses German short-rows to shape the shoulders below the textured saddles, the curved hems, and the sleeve caps. The textured garter-stripe edging that borders the sides and hem is worked along with the body until the hem shaping, then applied seamlessly using additional short-rows to curve smoothly around the corners.

FINISHED SIZE
About 34¼ [36, 40, 44, 48]" [87 [91.5, 101.5, 112, 122] cm] bust circumference. Sweater shown measures 36" [87 cm].

YARN
DK weight [#3 Light].

Shown here: Elsebeth Lavold Silky Wool [45% wool, 35% silk, 20% nylon; 192 yd [175 m]/1¾ oz [50 g]]: Pale Ale, 6 [6, 7, 8, 9] hanks.

NEEDLES
Size U.S. 5 [3.75 mm]: 32" [80 cm] and 16" [40 cm] circular [cir]. *Adjust needle size if necessary to obtain the correct gauge.*

NOTIONS
2 stitch markers [m]; 1 stitch holder; smooth waste yarn; yarn needle; six ¾" [20 mm] buttons; matching sewing thread and needle.

GAUGE
22 sts and 28 rows = 4" [10 cm] in St st.

Notes

The textured shoulder saddles are cast on and worked first, then stitches are picked up for the back; shoulders are shaped with a few short-rows and worked to the under-arm level, where stitches are cast on for the body and the worked-in side buttonbands. The hem is shaped with short-rows while the band stitches are put on hold, then the bottom edging is applied seamlessly as a continuation of the buttonbands. The front is worked similarly to the back, with the addition of neck shaping. Sleeve stitches are picked up around the modified dropped armhole, and the sleeve cap is shaped with short-rows for a comfortable fit, then worked in stockinette to the narrow garter cuffs. The matching garter neckline is picked up and worked in the round.

Stitch Guide

SHOULDER STITCH PATTERN (worked over 16 sts)
Row 1: [WS] K3, [p2, k2] to last 5 sts, p2, k3.

Row 2: [RS] Knit.

Rep Rows 1 and 2 for patt.

Double stitch (DS): On RS, move yarn to front between needles, sl 1, move yarn to back over needle; on WS, sl 1, move yarn to back over needle, move yarn to front between needles.

Make buttonhole (MB): Sl 1 knitwise, move yarn to front and drop it. *Sl 1 knitwise and pass first slipped st over second slipped st and off needle; rep from * twice more. Slip last st on right needle back to left needle. Turn work and move yarn to front; CO 4 using twisted purlwise cast-on. Turn work. Slip first st on left needle to right needle and slip last CO st over this st. Then slip this st onto left needle. Twisted purlwise cast-on: Insert right needle purlwise into first st on left needle; draw a loop of yarn through and place on left needle.

SHOULDER SADDLES [MAKE 2]

Using long-tail method, CO 16 sts. Work Shoulder Stitch Pattern for 28 (32, 34, 36, 40) rows. BO all sts and cut yarn.

BACK

With RS facing, beg at CO edge, pick up and knit 22 (24, 26, 28, 30) sts along long edge of one shoulder saddle, place marker (pm), CO 34 (35, 36, 37, 38) sts using backward-loop method, pm, then with RS facing, beg at BO edge, pick up and knit 22 (24, 26, 28, 30) sts along long edge of second shoulder saddle—78 (83, 88, 93, 98) sts.

Purl 1 WS row.

Shape Back Shoulders

SHORT-ROW 1: (RS) Knit to second m, k5 (6, 6, 7, 7), turn.

SHORT-ROW 2: (WS) DS, purl to second m, p5 (6, 6, 7, 7), turn.

SHORT-ROW 3: DS, knit to previous double st, knit both loops together as 1 st, k5 (6, 6, 7, 7), turn.

SHORT-ROW 4: DS, purl to previous double st, purl both loops together as 1 st, p5 (6, 6, 7, 7), turn.

SHORT-ROW 5: DS, knit to previous double st, knit both loops together as 1 st, k6 (6, 7, 7, 8), turn.

SHORT-ROW 6: DS, purl to previous double st, purl both loops together as 1 st, p6 (6, 7, 7, 8), turn.

ROW 7: DS, knit to previous double st, knit both loops together as 1 st, knit to end.

ROW 8: DS, purl to previous double st, purl both loops together as 1 st, purl to end, removing all markers.

Work 38 (42, 46, 52, 56) more rows in St st, working both loops of rem double sts together on the first row, or until armhole edge measures 5¾ (6¼, 6¾, 7¾, 8¼)" (14.5 [16, 17, 19.5, 21] cm) from shoulder saddle pick-up.

Shape Armhole and Begin Buttonband

SET-UP ROW: (RS) CO 12 (15, 18, 21, 24) sts using cable method (see Techniques), k14, pm, knit to end—90 (98, 106, 114, 122) sts.

SET-UP ROW: (WS) CO 12 (15, 18, 21, 24) sts using cable method, k3, p8, k3, pm, purl to next m, k3, p8, k3—102 (113, 124, 135, 146) sts; 74 (85, 96, 107, 118) sts between markers.

ROW 1: (RS) Knit.

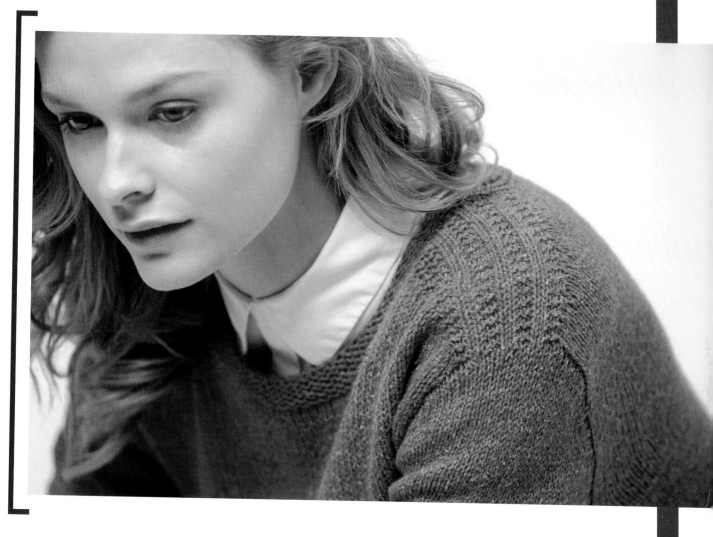

ROW 2: (WS) K3, p8, k3, sl m, purl to next m, k3, p8, k3.

ROW 3: Knit.

ROW 4: Knit to m, purl to next m, knit to end.

ROW 5: Knit.

ROW 6: Knit to m, purl to next m, knit to end.

Rep Rows 1–6 twelve more times, decreasing 1 (0, 2, 1, 0) st(s) between markers on last row for a multiple of 3 sts plus 1 between markers—101 (113, 122, 134, 146) sts rem; 73 (85, 94, 106, 118) sts between markers.

Back Hem

SHORT-ROW 1: (RS) Knit to 1 st before second m, turn.

SHORT-ROW 2: (WS) DS, purl to 1 st before m, turn.

SHORT-ROW 3: DS, knit to 1 st before previous double st, turn.

SHORT-ROW 4: DS, purl to 1 st before previous double st, turn.

Rep Short-rows 3 and 4 nine more times.

NEXT ROW: (RS) DS, knit to end, knitting both loops of each double st together as 1 st.

NEXT ROW: (WS) K3, p8, k3, purl to next m, k3, p8, k3.

SHORT-ROW 1: (RS) K5, turn.

SHORT-ROW 2: (WS) DS, p1, k3.

SHORT-ROW 3: K10, knitting both loops together as 1 st, turn.

SHORT-ROW 4: DS, p6, k3.

ROW 5: Knit to m, knitting both loops together as 1 st, sl m, k2tog-tbl, turn—1 body st dec'd.

ROW 6: Sl 1 wyf, sl m, knit to end.

ROW 7: Knit to m, sl m, k2tog-tbl, turn—1 body st dec'd.

4 (4¼, 4¾, 5, 5½)"
10 (11, 12, 12.5, 14) cm

3¾"
9.5 cm

6¼ (6¼, 6½, 6¾, 7)"
16 (16, 16.5, 17, 18) cm

16¾"
42.5 cm

1½"
3.8 cm

7¼ (7¾, 8¼, 9¼, 9¾)"
18.5 (19.5, 21, 23.5, 25) cm

FRONT & BACK

8 (8¼, 8¾, 9, 9½)"
20.5 (21, 22, 23, 24) cm

17¼"
44 cm

12 (13, 15, 16, 17)"
30.5 (33, 38, 40.5, 43) cm

35¾ (40, 44, 48, 51¾)"
90.5 (101.5, 112, 122, 131.5) cm

ROW 8: Sl 1 wyf, sl m, knit to end.

ROW 9: Knit to m, sl m, k2tog-tbl, turn—1 body st dec'd.

ROW 10: Sl 1 wyf, sl m, k3, p8, k3.

Rep last 10 rows 6 more times—52 (64, 73, 85, 97) sts rem between markers.

Then rep Rows 5–10 eleven (fifteen, eighteen, twenty-two, twenty-six) times—19 sts rem between markers.

Rep Rows 1–10, five times, then Rows 1–8 once, then Short-rows 1–4 once—30 sts total rem.

K15, leaving sts on needle. Place rem 15 sts on another needle, cut yarn and graft as follows:

SET-UP: Insert needle through first st on front needle purlwise, then through first st on back needle knitwise.

FRONT NEEDLE: Insert needle through first st knitwise and drop st off needle, then through next st purlwise, leaving st on needle.

BACK NEEDLE: Insert needle through first st purlwise and drop st off needle, then through next st knitwise, leaving st on needle.

Rep Front Needle and Back Needle steps until all sts are grafted.

FRONT

With RS facing and back neck CO edge at top, beg at inner neck edge, pick up and knit 22 (24, 26, 28, 30) sts along open long edge of left shoulder saddle.

Shape Left Front Shoulder

ROW 1: (WS) Purl to end.

SHORT-ROW 2: (RS) K5 (6, 6, 7, 7), turn.

SHORT-ROW 3: DS, purl to end.

SHORT-ROW 4: Knit to double st, knit both loops together as 1 st, k5 (6, 6, 7, 7), turn.

SHORT-ROW 5: DS, purl to end.

SHORT-ROW 6: Knit to double st, knit both loops together as 1 st, k6 (6, 7, 7, 8), turn.

NEXT ROW: (WS) DS, purl to end.

Shape Left Front Neck

NEXT ROW: (RS) K1, M1R, knit to end—1 st inc'd.

NEXT ROW: (WS) Purl.

Rep last 2 rows 3 more times—26 (28, 30, 32, 34) sts.

Cut yarn and place left front sts on holder.

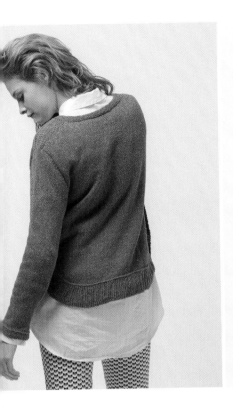

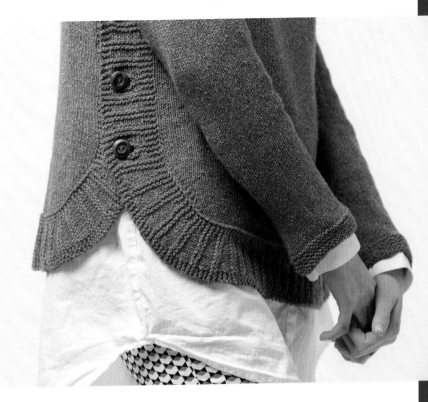

With RS facing and back neck CO edge at top, beg at outer armhole edge, pick up and knit 22 (24, 26, 28, 30) sts along open long edge of right shoulder saddle.

Shape Right Front Shoulder

SHORT-ROW 1: (WS) P5 (6, 6, 7, 7), turn.

SHORT-ROW 2: (RS) DS, knit to end.

SHORT-ROW 3: Purl to double st, purl both loops together as 1 st, p5 (6, 6, 7, 7), turn.

SHORT-ROW 4: DS, knit to end.

SHORT-ROW 5: Purl to double st, purl both loops together as 1 st, p6 (6, 7, 7, 8), turn.

SHORT-ROW 6: DS, knit to end.

NEXT ROW: (WS) Purl to double st, purl both loops together as 1 st, purl to end.

Shape Right Front Neck

NEXT ROW: (RS) Knit to last st, M1L, k1—1 st inc'd.

NEXT ROW: (WS) Purl.

Rep last 2 rows 3 more times—26 (28, 30, 32, 34) sts.

Join Right and Left Front

NEXT ROW: (RS) Using working yarn, knit across all sts of right front, CO 26 (27, 28, 29, 30) sts using backward-loop method, then knit left front sts from holder—78 (83, 88, 93, 98) sts.

Work 29 (33, 37, 43, 47) more rows in St st, or until armhole edge measures 5¾ (6¼, 6¾, 7¾, 8¼)" (14.5 [16, 17, 19.5, 21] cm) from shoulder saddle pick-up.

Shape Armhole and Begin Buttonband

SET-UP ROW: (RS) CO 12 (15, 18, 21, 24) sts using cable method, k14, pm, knit to end—90 (98, 106, 114, 122) sts.

SET-UP ROW: (WS) CO 12 (15, 18, 21, 24) sts using cable method, k3, p8, k3, pm, purl to next m, k3, p8, k3—102 (113, 124, 135, 146) sts.

ROW 1: (RS) Knit.

ROW 2: (WS) K3, p8, k3, sl m, purl to next m, k3, p8, k3.

ROW 3: Knit.

ROW 4: Knit to m, purl to next m, knit to end.

ROW 5: Knit.

ROW 6: Knit to m, purl to next m, knit to end.

Rep Rows 1–6 twelve more times, AT THE SAME TIME make 3 buttonholes by working every fourth Row 5 as follows:

Buttonhole row 5: [RS] K5, MB, knit to last 10 sts, MB, k5.

Front Hem
Work as for Back Hem.

SLEEVES
Overlap front over back at side seams so that 8 (14, 14, 14, 14) sts of 14-st textured buttonbands line up and tack in place temporarily using smooth waste yarn.

With RS facing, beg at center bottom of armhole, pick up and knit 8 (8, 11, 14, 17) sts with first 4 (7, 7, 7, 7) sts through both layers, along CO sts of underarm, 19 (22, 24, 25, 25) sts evenly spaced around armhole edge to shoulder saddle, 12 (12, 12, 10, 10) sts along edge of shoulder saddle, 19 (22, 24, 25, 25) sts evenly spaced around other armhole edge to underarm, and 8 (8, 11, 14, 17) sts with last 4 (7, 7, 7, 7) sts through both layers, along rem CO sts of underarm; pm and join to work in the rnd—66 (72, 82, 88, 94) sts.

Shape Sleeve Cap
SET-UP SHORT-ROW 1: (RS) K44 (48, 54, 58, 62), turn.

SET-UP SHORT-ROW 2: (WS) DS, p21 (23, 25, 27, 29), turn.

SHORT-ROW 1: DS, knit to previous double st, knit both loops together as 1 st, k1, turn.

SHORT-ROW 2: DS, purl to previous double st, purl both loops together as 1 st, p1, turn.

Rep Short-rows 1 and 2 until 1 st rem unworked on each side of marker.

Knit 7 (6, 4, 3, 3) rnds, knitting rem loops together as 1 st.

DEC RND: K1, ssk, knit to 3 sts before m, k2tog, k1—2 sts dec'd.

Rep Dec rnd every 8 (7, 5, 5, 4) rnds 6 (11, 9, 2, 12) more times, then every 9 (8, 6, 5, 5) rnds 4 (1, 7, 16, 8) time(s)—44 (46, 48, 50, 52) sts rem.

Knit 14 more rnds.

Cuff
RND 1: Knit.

RND 2: Purl.

Rep Rnds 1 and 2 four more times.

Bind off all sts knitwise.

FINISHING
Neck Edge
With RS facing and beg at CO sts of right back neck, pick up and knit 26 (28, 29, 29, 30) sts from CO sts of back neck, 10 sts from left shoulder saddle, 10 sts from left front neck edge, 19 (20, 21, 21, 22) sts from CO sts of front neck, 10 sts from right front neck edge, and 10 sts from right shoulder saddle; pm and join to work in the rnd—85 (88, 90, 90, 92) sts.

NEXT RND: Purl.

NEXT RND: Knit.

Rep last 2 rnds 3 more times, then purl 1 rnd.

Bind off all sts knitwise.

Weave in ends and block. Sew buttons to buttonband of back piece opposite buttonholes of front piece.

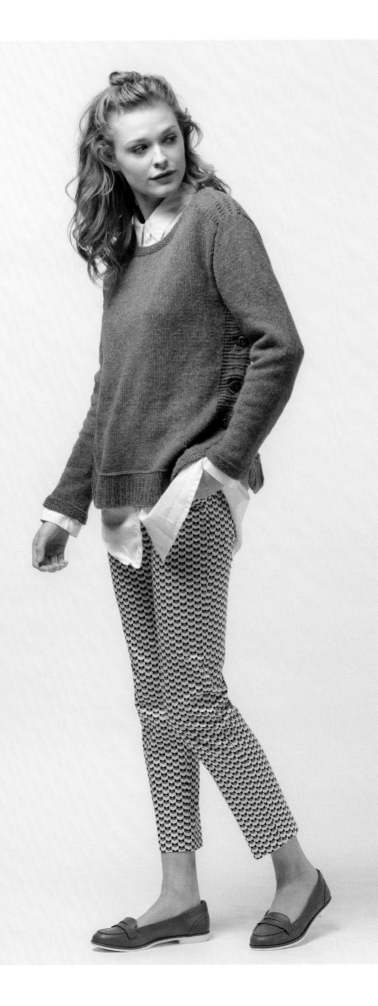

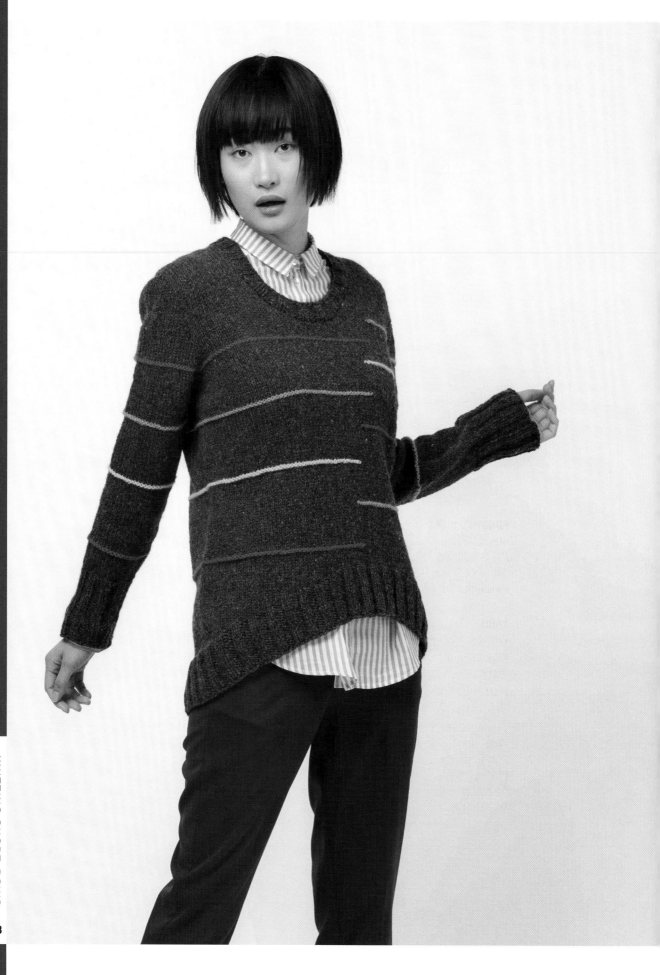

broken lines
PULLOVER

Contrasting short-row broken lines provide
a pop of color and texture, while additional
short-rows shape the shoulders and the
rounded hem. Worked seamlessly from the
top down with simultaneous set-in sleeves,
this sweater uses German short-rows
for both construction and detail.

FINISHED SIZE
About 32 [36, 40, 44, 48]" [81.5
[91.5, 101.5, 112, 122] cm] bust
circumference. Pullover shown
measures 36" [91.5 cm].

YARN
Worsted weight [#4 Medium].

Shown here: Harrisville Designs
WATERshed [100% wool; 110 yd
[101 m]/1¾ oz [50 g]]: Stonewall
[MC], 8 [9, 10, 11, 12] skeins.

Stonehedge Fiber Mill Shepherd's
Wool Worsted [100% merino wool;
250 yd [229 m]/4 oz
[113 g]]: 090314 Lilac [CC1],
122214 Raspberry [CC2], and
042914 Peach [CC3], 1 skein each.

NEEDLES
Size U.S. 8 [5 mm]: 32" [80 cm]
circular [cir]. *Adjust needle size if
necessary to obtain the correct
gauge.*

NOTIONS
6 stitch markers, 4 color A and 2
color B [m]; 1 removable marker;
stitch holders; yarn needle.

GAUGE
18 sts and 24 rows = 4" [10 cm] in
St st.

Notes

The seamless, simultaneous set-in sleeve method allows you to work the back, front, and sleeves at one time from the top down, while creating a tailored set-in sleeve fit. Stitches are cast on for the back, and the back shoulders are shaped with a few short-rows to create the shoulder slope; stitches are then picked up for each front shoulder, which is shaped with identical short-rows. The back and fronts are united, while at the same time stitches are picked up at the shoulder edges for the sleeve caps, and sleeve-cap shaping begins. The back, front, and sleeves are worked simultaneously to the bottom of the armscye, with neckline, sleeve-cap, and armhole shaping.

The stripes add about ¼" (.5 cm) per 2-row stripe in length. On the sleeves, include these rows when counting for sleeve shaping; on the body, insert these rows without counting them when following the instructions. The body is worked "to length", and so the schematic is not affected; likewise, the extra stripe length is accounted for in the sleeve length from the underarm. The armscyes have an extra 2 (2, 3, 3, 4) stripes on the sleeves (with the extra third stripe being on the left armhole for those sizes), and this is not represented in the schematic.

Stitch Guide

K2, P2 Rib: (worked in the rnd, multiple of 4 sts)

Rnd 1: *K2, p2; rep from * to end.

Rep Rnd 1 for patt.

Double stitch (DS): On RS, move yarn to front between needles, sl 1, move yarn to back over needle; on WS, sl 1, move yarn to back over needle, move yarn to front between needles.

BACK

Using cable method (see Techniques) and MC, CO 62 (65, 68, 71, 72) sts.

Knit 1 RS row.

SET-UP ROW: (WS) P18 (19, 19, 20, 20), place marker (pm), p26 (27, 30, 31, 32), pm and place a removable marker as well to mark left neck edge for picking up left front shoulder sts later,

purl to end. Do not move removable m up as work progresses.

Shape Left Back Shoulder

SHORT-ROW 1: (RS) Knit to first m, sl m, k1, turn.

SHORT-ROW 2: (WS) DS, sl m, p7 (7, 7, 8, 8), turn.

SHORT-ROW 3: DS, knit to previous double st, knit both loops together as 1 st, k1, turn.

SHORT-ROW 4: DS, purl to previous double st, purl both loops together as 1 st, p6 (6, 6, 7, 7), turn.

SHORT-ROW 5: DS, knit to previous double st, knit both loops together as 1 st, k1, turn.

SHORT-ROW 6: DS, purl to previous double st, purl both loops together as 1 st, purl to end.

Shape Right Back Shoulder

SHORT-ROW 1: (RS) Knit to previous double st, knit both loops together as 1 st, knit to second m, sl m, k7 (7, 7, 8, 8), turn.

SHORT-ROW 2: (WS) DS, purl to first m, sl m, p1, turn.

SHORT-ROW 3: DS, knit to previous double st, knit both loops together as 1 st, k6 (6, 6, 7, 7), turn.

SHORT-ROW 4: DS, purl to previous double st, purl both loops together as 1 st, p1, turn.

SHORT-ROW 5: DS, knit to previous double st, knit both loops together as 1 st, knit to end.

SHORT-ROW 6: Purl to previous double st, purl both loops together as 1 st, p1, turn.

SHORT-ROW 7: DS, knit to end.

NEXT ROW: (WS) Purl to previous double st, purl both loops together as 1 st, purl to end, removing m on the needle, but leaving the removable m placed in the st at the neck edge.

Work 2 rows in St st, ending with a WS row.

Cut yarn and place sts on holder.

FRONT
Shape Right Front Shoulder

ROW 1: With RS facing and MC, CO edge at the top, beg at right shoulder edge, pick up and knit 18 (19, 19, 20, 20) sts from CO edge. Turn work.

SHORT-ROW 2: (WS) P7 (7, 7, 8, 8), turn.

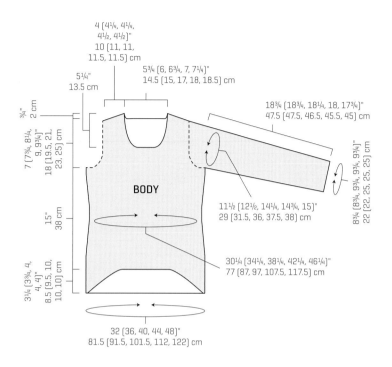

4 [4¼, 4¼, 4½, 4½]"
10 [11, 11, 11.5, 11.5] cm

5¼"
13.5 cm

5¾ [6, 6¾, 7, 7¼]"
14.5 [15, 17, 18, 18.5] cm

¾"
2 cm

18¾ [18¾, 18¼, 18, 17¾]"
47.5 [47.5, 46.5, 45.5, 45] cm

7 [7¾, 8¼, 9, 9¾]"
18 [19.5, 21, 23, 25] cm

8¾ [8¾, 9¾, 9¾, 9¾]"
22 [22, 25, 25, 25] cm

BODY

11½ [12½, 14¼, 14¾, 15]"
29 [31.5, 36, 37.5, 38] cm

15"
38 cm

30¼ [34¼, 38¼, 42¼, 46¼]"
77 [87, 97, 107.5, 117.5] cm

3¼ [3¾, 4, 4, 4]"
8.5 [9.5, 10, 10, 10] cm

32 [36, 40, 44, 48]"
81.5 [91.5, 101.5, 112, 122] cm

SHORT-ROW 3: (RS) DS, knit to end.

SHORT-ROW 4: Purl to previous double st, purl both loops together as 1 st, p6 (6, 6, 7, 7), turn.

SHORT-ROW 5: DS, knit to end.

ROW 6: Purl to previous double st, purl both loops together as 1 st, purl to end.

Work 6 more rows in St st, ending with a WS row. Cut yarn and place right front shoulder sts on holder.

Shape Left Front Shoulder

With RS facing and MC, CO edge at the top, beg at removable m placed at left neck edge, pick up and knit 18 (19, 19, 20, 20) st from CO edge. Turn work.

ROW 2: (WS) Purl to end.

SHORT-ROW 3: (RS) K7 (7, 7, 8, 8), turn.

SHORT-ROW 4: DS, purl to end.

SHORT-ROW 5: Knit to previous double st, knit both loops together as 1 st, k6 (6, 6, 7, 7), turn.

SHORT-ROW 6: DS, purl to end.

ROW 7: Knit to previous double st, knit both loops together as 1 st, knit to end.

Work 5 more rows in St st, ending with a WS row; do not cut yarn.

Join Front and Back, and Begin Sleeve Caps

NEXT ROW: (RS, increase sleeves) Knit to 1 st before end of Left Front Shoulder sts, pm, M1L, k1, pick up and knit 10 (10, 12, 12, 12) sts from edge of left shoulder, k1 from Back sts, M1R, pm, knit to 1 st before end of Back sts, pm, M1L, k1, pick up and knit 10 (10, 12, 12, 12) sts from edge of right shoulder, k1 from Right Front Shoulder sts, M1R, pm, knit to end—122 (127, 134, 139, 140) sts: 17 (18, 18, 19, 19) sts each front, 14 (14, 16, 16, 16) sts each sleeve, 60 (63, 66, 69, 70) back sts.

NEXT ROW: (WS, increase sleeves) [Purl to m, sl m, M1RP, purl to next m, M1LP, sl m] twice, purl to end—4 sts inc'd.

Sleeve, front neckline, and armhole shaping occur at the same time and at varying rates for each size. Instructions are broken out into sections; work the following instructions sequentially:

INCREASE SLEEVES EVERY ROW: Work next 2 rows, 2 (1, 0, 0, 0) time(s).

NEXT ROW: (RS, increase sleeves) [Knit to m, sl m, M1L, knit to m, M1R, sl m] twice, knit to end—4 sts inc'd.

NEXT ROW: (WS, increase sleeves) [Purl to m, sl m, M1RP, purl to next m, M1LP, sl m] twice, purl to end—4 sts inc'd.

INCREASE SLEEVES EVERY RS ROW: Work next 2 rows 0 (1, 2, 2, 2) time(s).

NEXT ROW: (RS, increase sleeves) [Knit to m, sl m, M1L, knit to m, M1R, sl m] twice, knit to end—4 sts inc'd.

NEXT ROW: (WS) Purl.

INCREASE SLEEVES AND FRONT NECKLINE EVERY RS ROW

Work next 2 rows 5 times.

NEXT ROW: (RS, increase sleeves and neck) K1, M1L, [knit to m, sl m, M1L, knit to m, M1R, sl m] twice, knit to last st, M1R, k1—6 sts inc'd.

NEXT ROW: (WS) Purl.

Increase sleeves every RS row and front neckline

EVERY ROW: Work next 2 rows twice.

NEXT ROW: (RS, increase sleeves and neck) K1, M1L, [knit to m, sl m, M1L, knit to m, M1R, sl m] twice, knit to last st, M1R, k1—6 sts inc'd.

NEXT ROW: (WS, increase neck) P1, M1RP, purl to last st, M1LP, p1—2 sts inc'd.

There are 188 (189, 192, 197, 198) sts: 26 (27, 27, 28, 28) sts each front, 38 (36, 36, 36, 36) sts each sleeve, 60 (63, 66, 69, 70) back sts.

CO Front Neck and Join Fronts

NEXT RND: (RS, increase sleeves and join fronts) [Knit to m, sl m, M1L, knit to m, M1R, sl m] twice, knit to end; CO 8 (9, 12, 13, 14) sts using backward-loop method and join for working in the rnd by knitting 26 (27, 27, 28, 28) sts of left front to first m, which becomes new end of rnd—12 (13, 16, 17, 18) sts inc'd; 200 (202, 208, 214, 216) sts: 40 (38, 38, 38, 38) sts each sleeve, 60 (63, 66, 69, 70) sts each front and back.

NEXT RND: Knit.

Work in patt as established, increasing sleeves and shaping armhole as indicated below and AT THE SAME TIME, begin inserting First Garter Short-row (SR) Stripe, then insert following Garter Short-row Stripes after every 8 MC rnds twice, then every 10 MC rnds twice, then every 12 MC rnds twice, then every 14 MC rnds once, for 8 Garter Short-row Stripes. Break CC yarn after each stripe.

First Garter SR CC1 Stripe

NOTE: Work Garter SR CC1 Stripe at the same time as the next increase sleeves rnd to start the stripe sequence.

NEXT RND: With MC, work as written to 17 sts before second m at right back, pmB, work as written to 17 sts before end of rnd, pmB; join CC1 and knit to end.

SHORT-ROW 1: (RS) With CC1, knit to first mB, turn.

SHORT-ROW 2: (WS) With CC1, DS, knit to 1 st before end of Stripe, sl 1, turn.

Finish rnd with MC and resume next rnd with MC.

INCREASE SLEEVES EVERY OTHER RND: Work next 2 rnds 1 (3, 3, 2, 1) time(s).

NEXT RND: (increase sleeves) [M1L, knit to m, M1R, sl m, knit to m, sl m] twice—4 sts inc'd.

NEXT RND: Knit.

INCREASE SLEEVES EVERY OTHER RND AND ARMHOLE EVERY 4TH RND: Work next 4 rnds 0 (0, 1, 2, 3) time(s).

RND 1: (increase sleeves and armhole) [M1L, knit to m, M1R, sl m, k1, M1L, knit to 1 st before m, M1R, k1, sl m] twice—8 sts inc'd.

RND 2: Knit.

RND 3: (increase sleeves) [M1L, knit to m, M1R, sl m, knit to m, sl m] twice—4 sts inc'd.

RND 4: Knit.

INCREASE SLEEVES AND ARMHOLE EVERY OTHER RND: Work next 2 rnds 4 (3, 3, 4, 4) times.

RND 1: (increase sleeves and armhole) [M1L, knit to m, M1R, sl m, k1, M1L, knit to 1 st before m, M1R, k1, sl m] twice—8 sts inc'd.

RND 2: Knit.

INCREASE SLEEVES EVERY OTHER RND AND ARMHOLE EVERY RND: Work next 2 rnds 1 (1, 1, 0, 0) time(s).

RND 1: (increase sleeves and armhole) [M1L, knit to m, M1R, sl m, k1, M1L, knit to 1 st before m, M1R, k1, sl m] twice—8 sts inc'd.

RND 2: (increase armhole) [Knit to m, sl m, k1, M1L, knit to 1 st before m, M1R, k1, sl m] twice—4 sts inc'd.

INCREASE ARMHOLE EVERY RND: Work next rnd, 0 (2, 2, 4, 6) times:

RND 1: (increase armhole) [Knit to m, sl m, k1, M1L, knit to 1 st before m, M1R, k1, sl m] twice—4 sts inc'd; 248 (258, 276, 294, 312) sts: 52 (52, 56, 58, 60) sts each sleeve, 72 (77, 82, 89, 96) sts each front and back.

Divide Body and Sleeves

NEXT RND: Removing sleeve m, place left sleeve sts on holder, CO 0 (4, 8, 10, 12) sts using backward-loop method and pm after first 0 (2, 4, 5, 6) sts for new end of rnd, knit to next m; removing sleeve m, place right sleeve sts on holder, CO 0 (4, 8, 10, 12) sts and pm after first 0 (2, 4, 5, 6) sts for side seam, knit to end of rnd—144, (162, 180, 198, 216) body sts rem. Knit 5" (12.5 cm) even.

Second Garter SR CC2 Stripe

SHORT-ROW 1: (RS) With MC, work as written to mB; join CC2 and knit to next mB, turn.

SHORT-ROW 2: (WS) With CC2, DS, knit to 1 st before end of Stripe, sl 1, turn.

Finish rnd with MC and resume next rnd with MC.

Third Garter SR CC3 Stripe

NEXT RND: With MC, work as written to 5 sts before second mB; join CC3 and knit to end.

SHORT-ROW 1: (RS) With CC3, knit to 5 sts before mB, turn.

SHORT-ROW 2: (WS) With CC3, DS, knit to 1 st before end of Stripe, sl 1, turn.

Finish rnd with MC and resume next rnd with MC.

Fourth Garter SR CC1 Stripe

SHORT-ROW 1: (RS) With MC, work as written to 5 sts before mB; join CC1 and knit to 5 sts before next mB, turn.

SHORT-ROW 2: (WS) With CC1, DS, knit to 1 st before end of Stripe, sl 1, turn.

Finish rnd with MC and resume next rnd with MC.

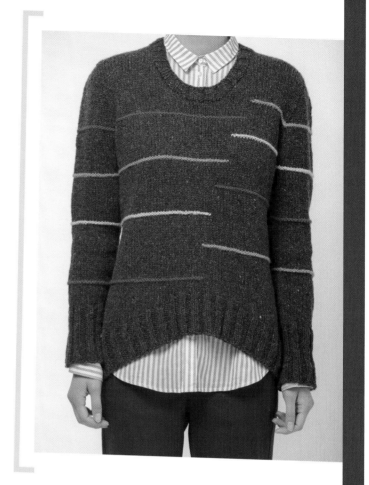

Fifth Garter SR CC2 Stripe

NEXT RND: With MC, work as written to 10 sts before second mB; join CC2 and knit to end.

SHORT-ROW 1: (RS) With CC2, knit to 10 sts before mB, turn.

SHORT-ROW 2: (WS) With CC2, DS, knit to 1 st before end of Stripe, sl 1, turn.

Finish rnd with MC and resume next rnd with MC.

Sixth Garter SR CC3 Stripe

SHORT-ROW 1: (RS) With MC, work as written to 10 sts before mB; join CC3 and knit to 10 sts before next mB, turn.

SHORT-ROW 2: (WS) With CC3, DS, knit to 1 st before end of Stripe, sl1, turn.

Finish rnd with MC and resume next rnd with MC.

Seventh Garter SR CC1 Stripe

NEXT RND: With MC, work as written to 15 sts before second mB; join CC1 and knit to end.

SHORT-ROW 1: (RS) With CC1, knit to 15 sts before mB, turn.

SHORT-ROW 2: (WS) With CC1, DS, knit to 1 st before end of Stripe, sl 1, turn.

Finish rnd with MC and resume next rnd with MC.

Eighth Garter SR CC2 Stripe

SHORT-ROW 1: (RS) With MC, work as written to 15 sts before mB; join CC2 and knit to 15 sts before next mB, turn.

SHORT-ROW 2: (WS) With CC2, DS, knit to 1 st before end of Stripe, sl 1, turn.

Finish rnd with MC and resume next rnd with MC.

Shape Body

DEC RND: [K1, k2tog, knit to 3 sts before m, ssk, k1, sl m] twice—4 sts dec'd.

Rep Dec rnd every 10th rnd once more—136 (154, 172, 190, 208) sts rem.

Work 9 rnds even.

INC RND: [K1, M1L, knit to 1 st before m, M1R, k1, sl m] twice—4 sts inc'd.

Rep Inc rnd every 10th rnd once more—144 (162, 180, 198, 216) sts.

Work even until sweater measures 12" (30.5 cm) from Body/Sleeve divide, or to desired length above front hem.

Shape Hem

SET-UP SHORT-ROW 1: (RS) Knit to m at right side seam, k29 (31, 35, 36, 40), turn.

SET-UP SHORT-ROW 2: (WS) DS, purl to end-of-rnd m at left side seam, p29 (31, 35, 36, 40), turn.

SHORT-ROW 1: DS, knit to 3 sts before previous turning point, turn.

SHORT-ROW 2: DS, purl to 3 sts before previous turning point, turn.

Rep Short-rows 1 and 2 eight (nine, ten, ten, ten) more times.

NEXT RND: (RS) DS, knit to end-of-rnd m, knit 1 rnd working both loops of double sts together, and AT THE SAME TIME, decrease 0 (2, 0, 2, 0) sts by working k2tog 0 (1, 0, 1, 0) time(s) at each side seam—144 (160, 180, 196, 216) sts.

Work in K2, P2 Rib for 3" (7.5 cm).

Bind off all sts in patt.

SLEEVES

Place 52 (52, 56, 58, 60) sleeve sts on needle; pick up and knit 0 (4, 8, 10, 12) sts from CO sts of armhole and pm after first 0 (2, 4, 5, 6) picked-up sts for end of rnd—52 (56, 64, 68, 72) sleeve sts.

Join for working in the rnd and knit 11 (9, 6, 5, 4) rnds even, maintaining stripe patt identical to body by working corresponding contrast color garter stripe in same location as on relevant side of body.

On the left sleeve, work 16, then 20, then 24 rnds between successive stripes. On the right sleeve, work 18, then 22, then 26 rnds between successive stripes.

DEC RND: K1, k2tog, knit to 3 sts before m, ssk, k1—2 sts dec'd.

Maintaining stripe patt, rep Dec rnd every 12 (10, 7, 6, 5) rnds 0 (0, 6, 4, 7) more times, then every 13 (11, 8, 7, 6) rnds 5 (6, 3, 6, 5) times—40 (42, 44, 46, 46) sts rem.

Knit 1" (2.5 cm) or to desired length before cuff and on last rnd dec 0 (2, 0, 2, 2) sts at sleeve seam using k2tog—40 (40, 44, 44, 44) sts rem.

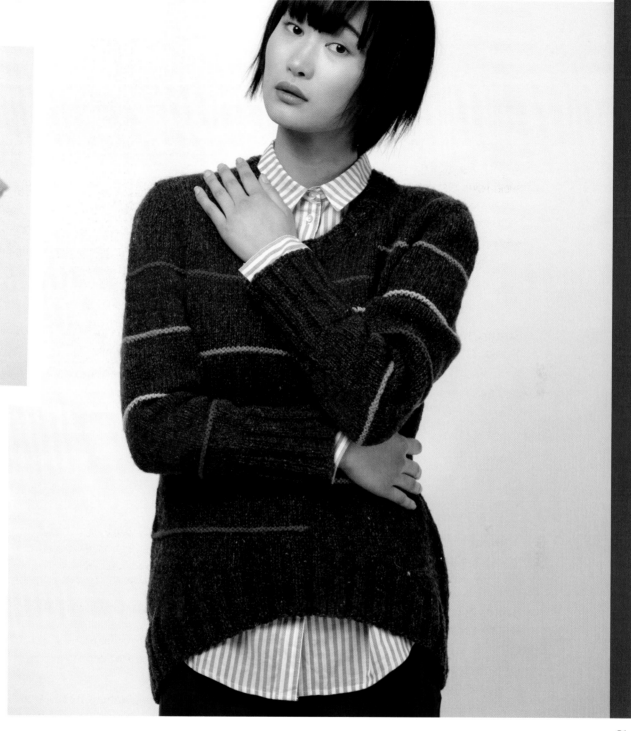

Cuff

With MC, work in K2, P2 Rib for 5" (12.5 cm).

Bind off all sts in patt.

FINISHING

Neck Edge

With RS facing and beg at CO sts of right back neck, pick up and knit 26 (26, 30, 30, 32) sts from CO sts of back neck, 13 sts from left side neck edge, 10 sts from left diagonal neck edge, 8 (8, 12, 12, 14) sts from CO sts of front neck, 10 sts from right diagonal neck edge, and 13 sts from right side neck edge—80 (80, 88, 88, 92) sts.

Work in K2, P2 Rib for 1" (2.5 cm).

Bind off all sts in patt.

Weave in ends and block.

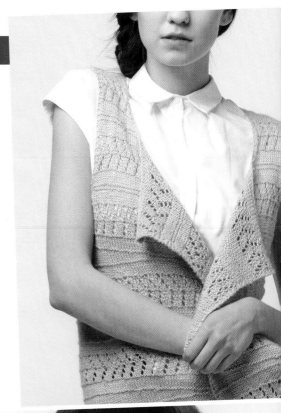

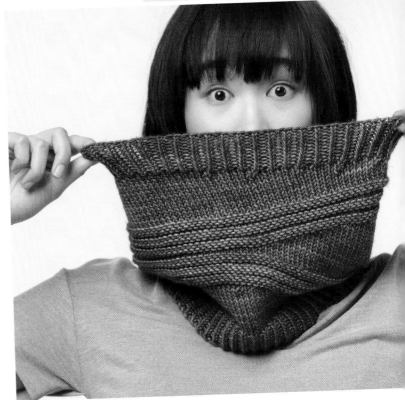

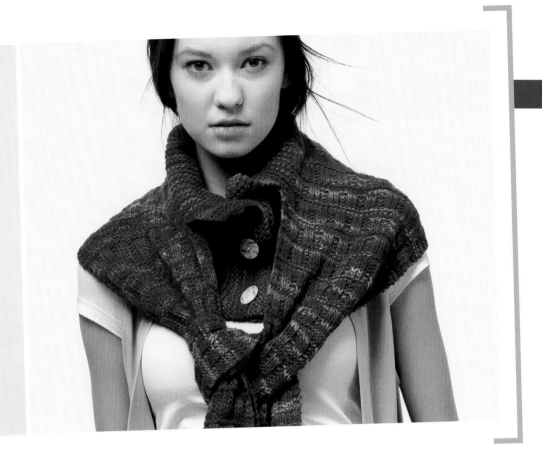

Chapter Four

THE JAPANESE METHOD

The Japanese method produces extremely tidy results in stockinette, garter stitch, and reverse stockinette. In the Japanese method, stitches are worked to the desired turning point, the work is turned, and the working yarn is marked. On a subsequent row, the marked yarn is pulled up to create an extra loop, which is worked together with the next stitch to disguise the turning point. This method requires a removable stitch marker, coil-less safety pin, or scrap yarn to mark the loop to be pulled up. This book uses the abbreviation "turn . . . sl1 & mark loop" as the instruction to mark the yarn for creating the extra loop.

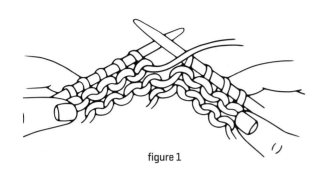

figure 1

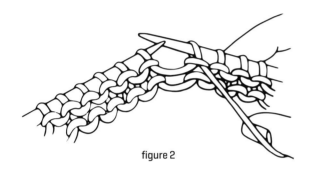

figure 2

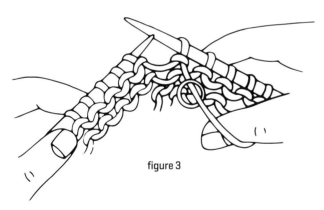

figure 3

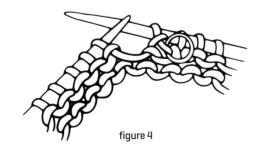

figure 4

THE JAPANESE METHOD ON A KNIT ROW

1 Knit to the turning point and turn the work (**Figure 1**).

2 Slip the next stitch purlwise (**Figure 2**).

3 Place a removable stitch marker on the working yarn at the front of the work (**Figure 3**). If you're working in garter stitch and need to move the yarn to the back between the needles, keep the stitch marker in front.

4 Purl the next row (**Figure 4**). If you're working in garter stitch, knit the next row.

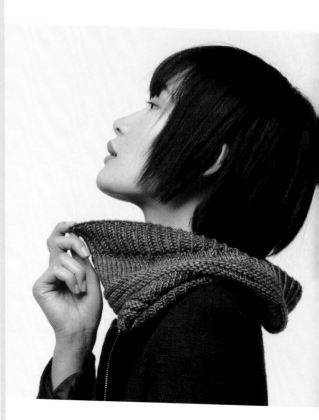

THE JAPANESE METHOD ON A PURL ROW

1 Purl to the turning point and turn the work (**Figure 1**).

2 Slip the next stitch purlwise (**Figure 2**).

3 Place a removable stitch marker on the working yarn at the back of the work (**Figure 3**).

4 Knit the next row (**Figure 4**).

There will be a gap at the turning point, to the left of the stitch that was slipped; pulling up a loop of yarn with the marker and working that loop together with the following stitch will close the gap. When working pattern stitches, follow the steps based upon where the stitch marker is located. In stockinette stitch on the knit side and on the RS of garter stitch, the stitch marker is at the back of the work; use the instructions for closing the gap on a knit row. In stockinette stitch on the purl side, use the instructions for closing the gap on a purl row.

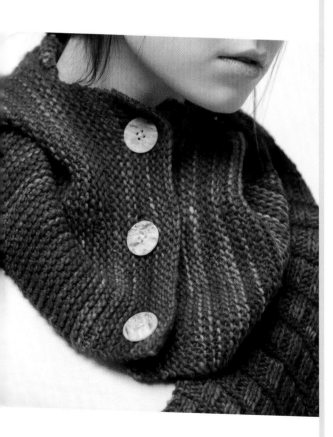

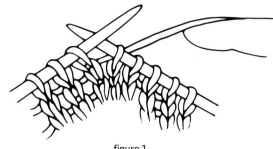

figure 1

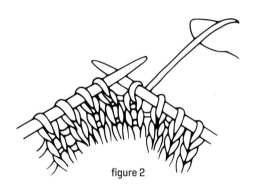

figure 2

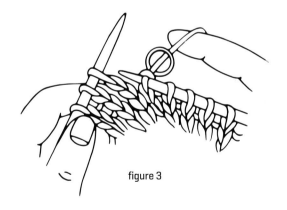

figure 3

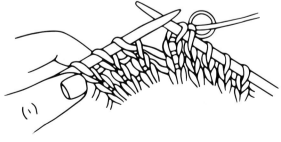

figure 4

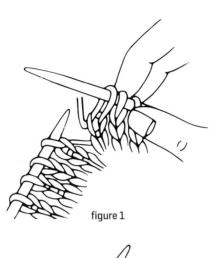

figure 1

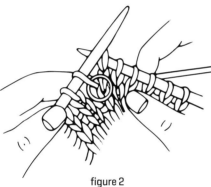

figure 2

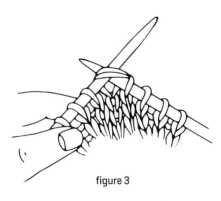

figure 3

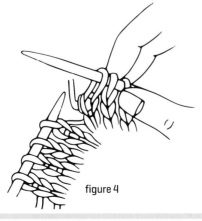

figure 4

TO CLOSE THE GAP ON A ROW WHEN THE MARKER IS AT THE BACK OF THE WORK

1 Knit to the gap; the stitch marker is at the back of the work (**Figure 1**).

2 Pull up a loop of yarn by pulling on the stitch marker without twisting it and place the untwisted loop on the left needle (**Figure 2**).

3 Remove the marker and insert the right needle tip knitwise into the next stitch and the loop (**Figure 3**).

4 Knit the loop and the stitch together as one (**Figure 4**).

TO CLOSE THE GAP ON A ROW WHEN THE MARKER IS AT THE FRONT OF THE WORK

1 Purl to the gap; the stitch marker is at the front of the work (**Figure 1**).

2 Slip the next stitch purlwise to the right needle (**Figure 2**).

3 Pull up a loop of yarn by pulling on the stitch marker without twisting it and place the untwisted loop on the left needle (**Figure 3**).

4 Slip the stitch on the right needle back to the left needle without twisting it and remove the marker (**Figure 4**).

5 Insert the right needle tip purlwise into the stitch and the loop (**Figure 5**).

6 Purl the stitch and the loop together as one (**Figure 6**).

To close the gap on a knit row that is the WS of garter stitch, follow the steps for closing the gap on a row with the marker in front, substituting knits for purls: knit to the gap and slip the next stitch purlwise. Pull up a loop with the marker that is on the front of the work, place the loop on the left needle, and slip the stitch on the right needle back to the left needle, then k2tog. This results in a visible loop on the WS; for reversible garter stitch that will be viewed from both sides, it might be better to use the instructions for closing the gap on a knit row and keep the marker on the RS, as the double stitch that results may blend fairly well into the garter stitch.

To work Japanese short-rows in reverse stockinette stitch, follow the same principles but always place the marker on the private (wrong) side of the work because that is where the extra loop will be visible. On a knit row, turn and move the yarn to the back before slipping the stitch, place the marker on the private side of the work, then bring the yarn to the front again and purl. On a purl row, turn and slip the stitch, then move the yarn to the private knit side on the front, place the marker, bring the yarn to the back again and knit. The extra step will feel odd, but

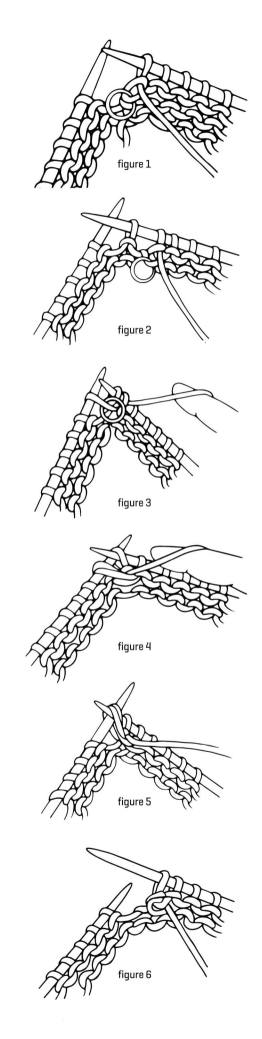

figure 1

figure 2

figure 3

figure 4

figure 5

figure 6

the point is to place the marker on the wrong side of the work; hold it with your finger if necessary to prevent it pivoting to the other side while working the next stitch.

When you close the gap in reverse stockinette, follow the instructions based on the location of the marker, substituting knit and purl as needed; on the purl RS of the work, purl to the gap, pull up a loop with the marker at the back of the work and place it on the left needle, then p2tog. On the knit WS of the work, knit to the gap and slip the next stitch, pull up a loop with the marker at the front of the work and place it on the left needle, slip the stitch back to the left needle, then k2tog.

The Japanese method, while it involves a bit of extra equipment, is very tidy and effective. Creating the loop without using any extra yarn minimizes its visibility in the finished fabric. If you don't have removable markers handy, or they seem bulky in smaller-gauge work, you can use scrap yarn. Either cut the yarn into individual lengths a few inches long or use one long strand for all the loops on a side. Lay the contrast yarn over the working yarn before knitting or purling the next row and use it to pull up the extra loop when disguising the turning point.

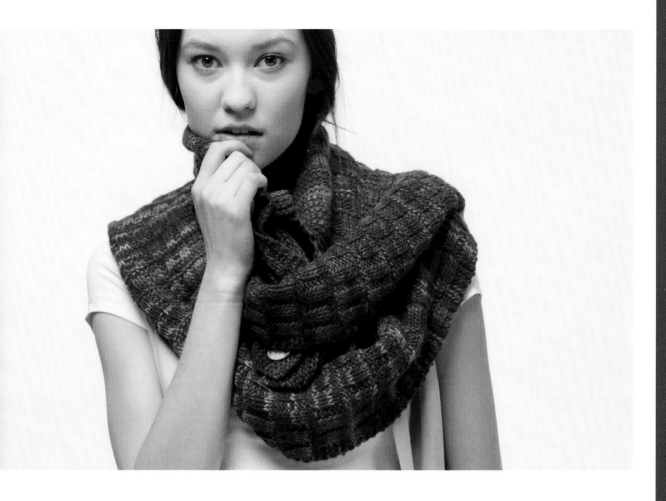

SPECIAL CONSIDERATIONS

Although this method involves pulling up a loop from the row below, there is minimal distortion because no excess yarn is used to create the loop; the resulting fabric looks neat in both stockinette and garter.

When working in garter stitch, be sure to place the stitch marker on the private side of the work, which is the front when you're on the wrong side, and the back on the right side; marking your fabric RS with a stitch marker helps as an easy reference. If the marker pivots to the RS of the work when you're moving your yarn for the next stitch, it will be visible when it's time to disguise the turning point on a subsequent row, and pulling up the yarn will result in a visible stretched loop on the RS of the work.

The Japanese method can also be adapted to working in the round. On the subsequent round, when you encounter a marker that was placed while working back in the opposite direction, the gap will be to the right of the marker, instead of to its left. To disguise the turning point, you will need to work the loop together with the stitch to the right across the gap. In stockinette stitch, work to one stitch before the gap, slip the next stitch knitwise, pull up a loop of yarn by pulling on the stitch marker and placing the loop on the left needle, slip the stitch on the right needle back to the left needle, and knit the stitch and loop together through the back loops. Use the same steps on a knit round of garter stitch in the round.

In reverse stockinette in the round, when you have turned a short-row and the purl side is facing you, move the yarn to the back before slipping the stitch, then mark the yarn on the private side of the work and bring it to the front again to work the purl row; this prevents the slipped stitch from torqueing by avoiding pulling the yarn across its front. To disguise the turning point, work to one stitch before the gap, slip the next stitch knitwise, pull up a loop of yarn by pulling on the stitch marker and placing the loop on the left needle, slip the stitch on the right needle back to the left needle, and purl the stitch and the loop together through the back loops. You might find that the loop of yarn is extremely tight when pulled up onto the needle, which helps make the resulting fabric very tidy, but requires attention while working; using a large stitch marker can help gain a little extra room in the loop.

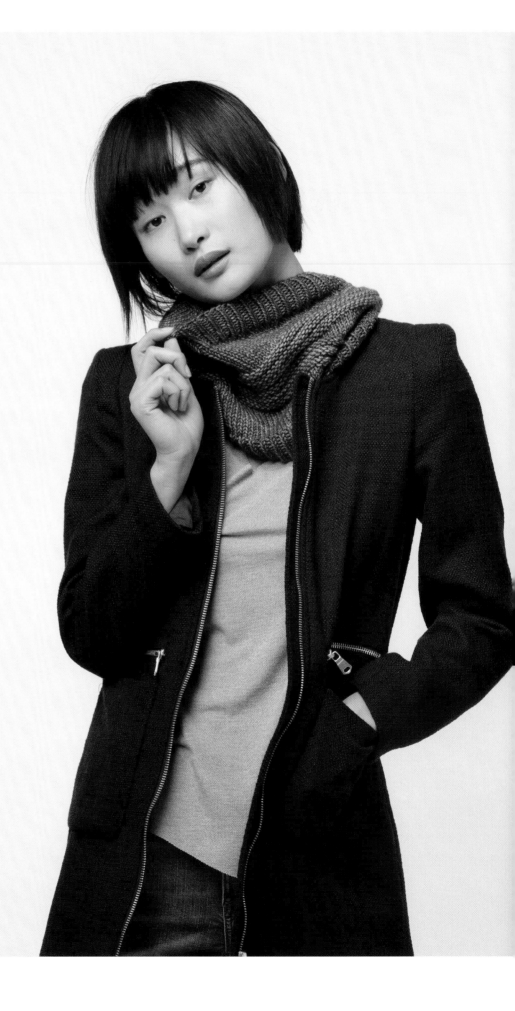

welts apart COWL

Wedges stack up between garter welts that meet and diverge in this cowl. Working the Japanese method in the round shapes the wedges in both directions, while twisted rib provides additional texture.

FINISHED SIZE
About 26" (66 cm) circumference and 10" (25.5 cm) tall.

YARN
Worsted weight (#4 Medium).

Shown here: Anzula For Better or Worsted (80% superwash merino wool, 10% cashmere, 10% nylon; 200 yd [182 m]/4 oz [115 g]): Prudence, 2 skeins.

NEEDLES
Size U.S. 8 (5 mm): 24" (60 cm) circular (cir). *Adjust needle size if necessary to obtain the correct gauge.*

NOTIONS
1 stitch marker (m); 28 removable markers; yarn needle.

GAUGE
17 sts and 24 rows = 4" (10 cm) in St st.

Stitch Guide

Sl 1 & mark loop: Sl 1 purlwise, place marker on working yarn, and work next row.

Twisted Rib: (worked in the rnd, multiple of 2 sts)

Rnd 1: *K1-tbl, p1; rep from * to end.

Rep Rnd 1 for patt.

COWL

Using cable method (see Techniques), CO 108 sts; place marker (pm) and join for working in the rnd, being careful not to twist sts.

Work 10 rnds in Twisted Rib patt.

Knit 2 rnds.

Short-row Wedge 1

SET-UP SHORT-ROW 1: (RS) Knit to 12 sts before m, turn.

SET-UP SHORT-ROW 2: (WS) Sl 1 & mark loop, purl to 12 sts before m, turn.

SHORT-ROW 1: (RS) Sl 1 & mark loop, knit to 6 sts before previous turning point, turn.

SHORT-ROW 2: (WS) Sl 1 & mark loop, purl to 6 sts before previous turning point, turn.

Rep Short-rows 1 and 2, four more times.

NEXT ROW: (RS) Sl 1 & mark loop, knit to end, working all marked loops tog with sts.

NEXT RND: (RS) Knit, working rem loops tog with sts.

Purl Welt

Purl 2 rnds, then knit 2 rnds.

Rep Purl Welt twice more.

Short-row Wedge 2

SET-UP SHORT-ROW 1: (RS) K40, turn.

SET-UP SHORT-ROW 2: (WS) Sl 1 & mark loop, purl to m, p40, turn.

SHORT-ROW 1: Sl 1 & mark loop, knit to 2 sts before previous turning point, turn.

SHORT-ROW 2: Sl 1 & mark loop, purl to 2 sts before previous turning point, turn.

Rep Short-rows 1 and 2 twelve more times.

NEXT ROW: Sl 1 & mark loop, knit to end.

NEXT RND: (RS) Knit, working all loops tog with sts.

Rep Purl Welt 3 times.

Rep Short-row Wedge 1 once.

Knit 2 rnds.

Work 10 rnds in Twisted Rib patt.

FINISHING

Bind off all sts loosely in patt.

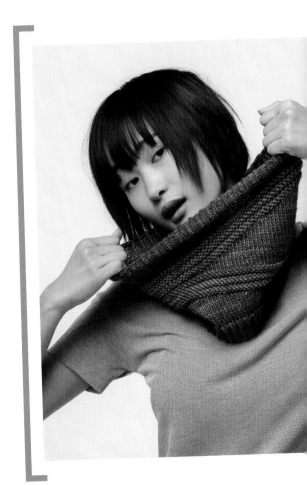

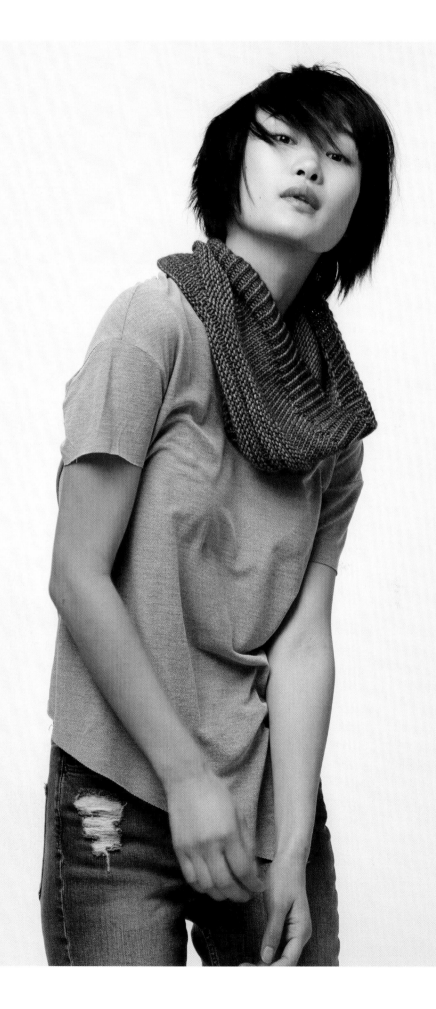

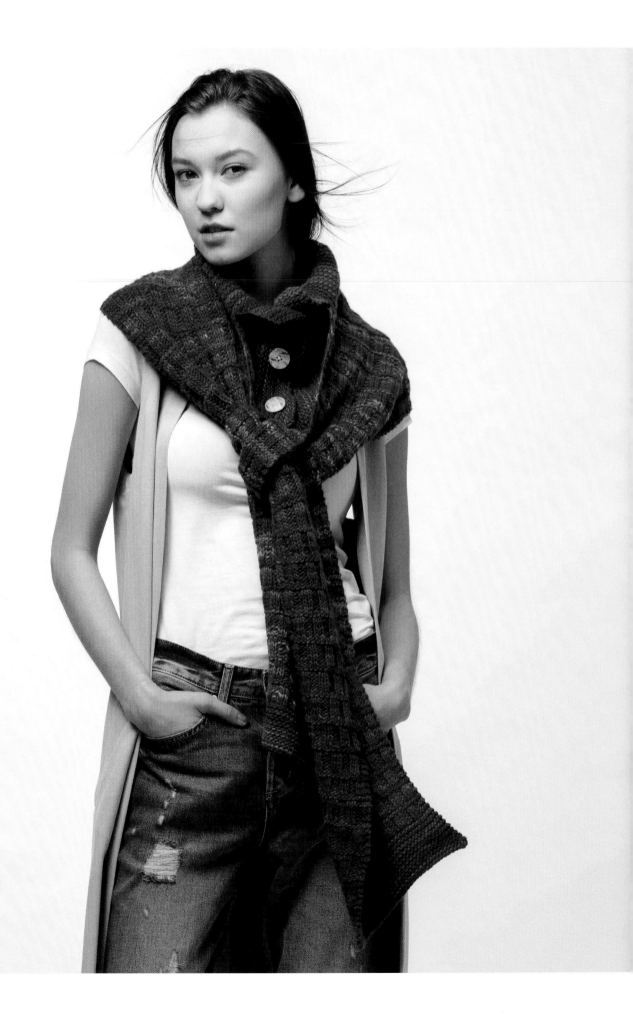

paving stones
SCOWL

In this hybrid neck-warmer that combines a scarf with a cowl, strategically placed short-rows using the Japanese method shape both the garter buttoned cowl and the textured foldover scarf. Button the shaped cowl around your neck to keep warm, then fling the reversible scarf ends around your shoulders for a dash of style.

FINISHED SIZE

About 32" [81.5 cm] wide at top edge of cowl and 10" [25.5 cm] tall, unbuttoned; scarf measures about 84" [213 cm] long and 8" [20.5 cm] tall.

YARN

Worsted weight [#4 Medium].

Shown here: Manos del Uruguay Maxima [100% extrafine merino wool; 219 yd [200 m]/3½ oz [100 g]]: M2414 Larkspur, 3 skeins.

NEEDLES

Size U.S. 9 [5.5 mm]: 24" [60 cm] circular [cir]. *Adjust needle size if necessary to obtain the correct gauge.*

NOTIONS

1 stitch marker [m]; 1 removable marker; stitch holder; yarn needle; three 1" [25 mm] buttons; matching sewing thread and needle.

GAUGE

16 sts and 32 rows = 4" [10 cm] in garter st; 16 sts and 24 rows = 4" [10 cm] in pattern stitch, measured in non–short-row section.

Notes

For this neck-warmer, the turning rows are placed in both k2, p2 rib rows and garter-stitch rows; work in pattern to the turning point, turn the work, slip 1 and mark the working yarn at the front of the work with the removable marker. The marked stitch is always worked in a knit row; knit to the turning point, pull up the marked loop of yarn, and place it on the left needle without twisting, then knit the loop together with the next stitch.

Stitch Guide

Sl 1 & mark loop: Sl 1 purlwise, place marker on working yarn, and work next row.

Make buttonhole (MB): Sl 1 knitwise, move yarn to front and drop it. *Sl 1 knitwise and pass first slipped st over second slipped st and off needle; rep from * twice more. Slip last st on right needle back to left needle. Turn work, and move yarn to front; CO 4 using twisted purlwise cast-on. Turn work. Slip first st on left needle to right needle, and slip last CO st over this st. Then slip this st onto left needle.

Twisted purlwise cast-on: Insert right needle purlwise into first st on left needle; draw a loop of yarn through and place on left needle.

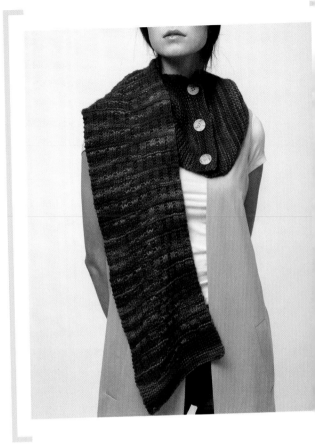

LEFT BUTTON PLACKET

Using cable method (see Techniques), CO 38 sts.

Beg with a WS row, knit 18 rows.

Cut yarn and place sts on holder.

LEFT SCARF

With new yarn and using cable method, CO 38 sts.

Beg with a RS row, knit 18 rows.

ROW 1: (RS) K2, *k2, p2; rep from * to last 4 sts, k4.

ROW 2: K2, *p2, k2; rep from * to end.

ROW 3: Rep Row 1.

ROW 4: Rep Row 2.

SHORT-ROW 5: K2, [k2, p2] 4 times, turn.

SHORT-ROW 6: Sl 1 & mark loop, k1, *p2, k2; rep from * to end.

ROW 7: Knit, working marked loop tog with st.

ROW 8: Knit.

ROW 9: K2, *p2, k2; rep from * to end.

ROW 10: K2, *k2, p2; rep from * to last 4 sts, k4.

ROW 11: Rep Row 9.

ROW 12: Rep Row 10.

SHORT-ROW 13: K2, [p2, k2] 4 times, turn.

SHORT-ROW 14: Sl 1 & mark loop, p1, *k2, p2; rep from * to last 4 sts, k4.

ROW 15: Knit, working marked loop tog with st.

ROW 16: Knit.

Rep Rows 1–16 ten more times.

COWL

NEXT ROW: (RS) K2, *k2, p2; rep from * to last 4 sts, k4, place marker (pm); with WS facing, knit 38 sts from holder—76 sts.

Work the following Rows 1–24, beg with Row 2:

ROW 1: (RS) K2, *k2, p2; rep from * to 4 sts before m, k4, sl m, knit to end.

ROW 2: Knit to m, sl m, k2, *p2, k2; rep from * to end.

ROW 3: Rep Row 1.

SHORT-ROW 4: K20, turn.

SHORT-ROW 5: Sl 1 & mark loop, knit to end.

SHORT-ROW 6: Knit to 6 sts before m working marked loop tog with st, turn.

SHORT-ROW 7: Sl 1 & mark loop, knit to end.

ROW 8: Knit to m working marked loop tog with st, sl m, k2, *p2, k2; rep from * to end.

SHORT-ROW 9: K2, [k2, p2] 4 times, turn.

SHORT-ROW 10: Sl 1 & mark loop, k1, *p2, k2; rep from * to end.

ROW 11: Knit, working marked loop tog with st.

ROW 12: Knit.

ROW 13: K2, *p2, k2; rep from * to m, sl m, knit to end.

ROW 14: Knit to m, sl m, k2, *k2, p2; rep from * to last 4 sts, k4.

ROW 15: Rep Row 13.

SHORT-ROW 16: K20, turn.

SHORT-ROW 17: Sl 1 & mark loop, knit to end.

SHORT-ROW 18: Knit to 6 sts before m working marked loop tog with st, turn.

SHORT-ROW 19: Sl1 and mark loop, knit to end.

ROW 20: Knit to m working marked loop tog with st, sl m, k2, *k2, p2; rep from * to last 4 sts, k4.

SHORT-ROW 21: K2, [p2, k2] 4 times, turn.

SHORT-ROW 22: Sl 1 & mark loop, p1, *k2, p2; rep from * to last 4 sts, k4.

ROW 23: Knit, working marked loop tog with st.

ROW 24: Knit.

Rep Rows 1–24 seven more times, then work Rows 1–23 once more.

NEXT ROW: K38 and place these sts on holder; knit to end—38 sts rem.

RIGHT SCARF
Rep Rows 1–16 of Left Scarf 11 times.

Knit 18 rows. Bind off all sts.

RIGHT BUTTON PLACKET
Place 38 held sts of cowl on needle; beg with a WS row, knit 8 rows.

NEXT ROW: (make buttonhole) K4, MB, k10, MB, k10, MB, k5 to end.

Knit 8 rows.

Bind off all sts.

The final stitch of the buttonhole is worked twice.

FINISHING
Weave in ends and block. With matching sewing thread and needle, sew buttons to Left Placket of cowl, opposite buttonholes.

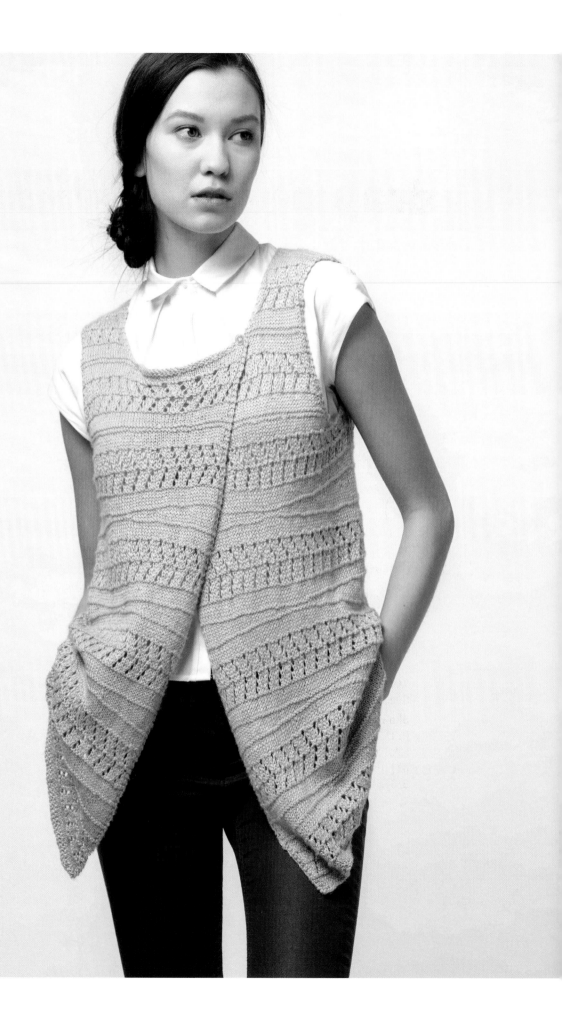

draping asymmetry
VEST

Worked seamlessly from the top down
in one piece, this long blanket-front vest
uses Japanese short-rows worked within
the horizontal pattern to create visual style
lines and a draping curved hem. Additional
short-rows shape the shoulders; the neck and
armhole edgings are worked simultaneously
with the body, eliminating finishing other
than adding two buttons at the top.

FINISHED SIZE
About 32 [36½, 39, 43½, 48]"
[81.5 [92, 99, 110.5, 122 cm] bust
circumference, based on 2 times
the back width. Sweater shown
measures 36½" [92 cm].

YARN
Sportweight [#2 Fine].

Shown here: HiKoo by Skacel Rylie
[50% baby alpaca, 25% mulberry
silk, 25% linen; 274 yd [251 m]/3½
oz [100 g]]: #89 Sea Glass, 4 [4, 5,
6, 6] skeins.

NEEDLES
Size U.S. 4 [3.5 mm]: 32" [80 cm]
circular [cir]. *Adjust needle size if
necessary to obtain the correct
gauge.*

NOTIONS
2 stitch markers [m]; 2 removable
markers; stitch holders; yarn
needle; two ½" [13 mm] buttons;
matching sewing thread and
needle.

GAUGE
22 sts and 28 rows = 4" [10 cm] in
Stripe Sequence pattern.

Notes

The back is cast on and shoulders shaped with short-rows, then worked in horizontal lace pattern to the armhole depth. Fronts are picked up from each cast-on shoulder, shaped with short-rows, then worked to the armhole depth with neck shaping and extended front panels. Fronts and back are joined and worked in lace pattern with short-rows adding length and drape at the side seams and front edges.

If front neck or armhole shaping occurs in the lace sections, work in stockinette stitch if not enough stitches exist to pair an increase with its accompanying decrease.

Stitch Guide

Sl 1 & mark loop: Sl 1 purlwise, place marker on working yarn, and work next row.

Stripe Sequence

LACE STRIPE (multiple of 4 sts + 4)

Row 1: [RS] K2, *yo, skp, k2; rep from * to last 2 sts, k2.

Rows 2, 4, 8, and 10: [WS] K2, purl to last 2 sts, k2.

Row 3: K2, *k1, yo, skp, k1; rep from * to last 2 sts, k2.

Row 5: K2, *k2, yo, skp; rep from * to last 2 sts, k2.

Row 6: Knit.

Row 7: K2, *k2, k2tog, yo; rep from * to last 2 sts, k2.

Row 9: K2, *k1, k2tog, yo, k1; rep from * to last 2 sts, k2.

Row 11: K2, *k2tog, yo, k2; rep from * to last 2 sts, k2.

Row 12: Knit.

PLAIN STRIPE

Row 1: [RS] Knit.

Row 2: [WS] K2, purl to last 2 sts, k2.

Row 3: Rep Row 1.

Row 4: Rep Row 2.

Rows 5 and 6: Knit.

GARTER STRIPE

Knit 2 rows.

Rep Plain Stripe once.

BACK

Using cable method (see Techniques), CO 72 (76, 80, 84, 88) sts.

SET-UP ROW: (WS) K20 (20, 24, 24, 24), place marker (pm), k32 (36, 32, 36, 40), pm and place a removable marker as well to mark left neck edge for picking up left front shoulder sts later, knit to end.

Shape Left Back Shoulder

SHORT-ROW 1: (RS) Knit to first m, turn.

SHORT-ROW 2: (WS) Sl 1 & mark loop, p6 (6, 7, 7, 7), turn.

SHORT-ROW 3: Sl 1 & mark loop, knit to previous turning point, knit loop tog with st, turn.

SHORT-ROW 4: Sl 1 & mark loop, purl to previous turning point, purl loop tog with st, p6 (6, 7, 7, 7), turn.

SHORT-ROW 5: Sl 1 & mark loop, knit to previous turning point, knit loop tog with st, turn.

SHORT-ROW 6: Sl 1 & mark loop, purl to previous turning point, purl loop tog with st, purl to last 2 sts, k2.

Shape Right Back Shoulder

SHORT-ROW 1: (RS) Knit to previous turning point, knit loop tog with st, knit to m, sl m, k7 (7, 8, 8, 8), turn.

SHORT-ROW 2: (WS) Sl 1 & mark loop, purl to m, turn.

SHORT-ROW 3: Sl 1 & mark loop, knit to previous turning point, knit loop tog with st, k6 (6, 7, 7, 7), turn.

SHORT-ROW 4: Sl 1 & mark loop, purl to previous turning point, purl loop tog with st, turn.

SHORT-ROW 5: Knit to previous turning point, knit loop tog with st, knit to end.

SHORT-ROW 6: K2, purl to previous turning point, purl loop tog with st, turn.

SHORT-ROW 7: Sl 1 & mark loop, knit to end.

NEXT ROW: (WS) Knit to previous turning point, knit loop tog with st, knit to end.

Work 34 (38, 42, 42, 42) rows in Stripe Sequence (Lace Stripe, Plain Stripe, Garter Stripe, Plain

LACE STRIPE

4-st rep

Symbol	Meaning
□	k on RS; p on WS
•	p on RS; k on WS
○	yo
╱	k2tog
╲	ssk or sl 1, k1, psso, [skp]
▢	pattern repeat

5¾ [6½, 5¾, 6½, 7¼]"
14.5 [16.5, 14.5, 16.5, 18.5] cm

3¾ [3¾, 4¼, 4¼, 4¼]"
9.5 [9.5, 11, 11, 11] cm

1½"
3.8 cm

5¾"
14.5 cm

7¼ [7¾, 8¼, 8¼, 9¼]"
18.5 [19.5, 21, 22, 23.5] cm

20¼ [19½, 21¾, 21¾, 24]"
51.5 [49.5, 55, 55, 61] cm

BODY

24½ [24, 23½, 22¾, 22½]"
62 [61, 59.5, 58, 57] cm

37¾ [43, 45¾, 49½, 54½]"
96 [109, 116, 125.5, 138.5] cm

Stripe), until piece measures 5¾ (6¼, 6¾, 6¾, 6¾)" (14.5 [16, 17, 17, 17] cm) from CO, measured at armhole edge.

Shape Armhole

INC ROW: (RS) K2, M1R, work in patt to last 2 sts, M1L, k2—2 sts inc'd.

Rep Inc row every other row 2 (2, 2, 3, 3) more times, ending with a WS row, then every row 4 (4, 4, 6, 8) times, using M1RP and M1LP in place of M1R and M1L if the Inc row is a WS purl row—86 (90, 94, 104, 112) sts.

Cut yarn and place back sts on holder.

FRONT
Shape Right Front Shoulder

ROW 1: With RS facing and CO edge at the top, beg at right shoulder edge, pick up and knit 20 (20, 24, 24, 24) sts from CO edge. Turn work.

SHORT-ROW 2: (WS) K2, p5 (5, 6, 6, 6), turn.

SHORT-ROW 3: (RS) Sl 1 & mark loop, knit to end.

SHORT-ROW 4: K2, purl to previous turning point, purl loop tog with st, p6 (6, 7, 7, 7), turn.

SHORT-ROW 5: Sl 1 & mark loop, knit to end.

ROW 6: K2, purl to previous turning point, purl loop tog with st, purl to last 2 sts, k2.

ROW 7: Knit to end.

NEXT ROW: (WS) Knit to end.

Work Lace Stripe over next 12 rows.

Shape Right Neck (Plain Stripe)

ROW 1: (RS) Knit to last 2 sts, M1L, k2—1 st inc'd.

ROW 2: (WS) K2, purl to last 2 sts, k2.

ROW 3: Rep Row 1—1 st inc'd.

ROW 4: Rep Row 2.

ROW 5: Rep Row 1—1 st inc'd.

ROW 6: Pm and, using cable method, CO 29 (33, 33, 33, 37) sts; knit to end—52 (56, 60, 60, 64) sts.

NEXT ROW: (RS, make buttonholes) Knit to m, yo, k2tog, knit to last 4 sts, yo, k2tog, k2.

NEXT ROW: (WS) Knit.

Work Plain Stripe (without shaping) over next 6 rows.

Work 8 (12, 16, 16, 16) more rows in Stripe Sequence (Lace Stripe, Plain Stripe, Garter Stripe,

Plain Stripe), until piece measures 5¾ (6¼, 6¾, 6¾, 6¾)" (14.5 [16, 17, 17, 17] cm) from CO, measured at armhole edge.

Shape Right Armhole

INC ROW: (RS) K2, M1R, work in patt to end—1 st inc'd.

Rep Inc row every other row 2 (2, 2, 3, 3) more times, ending with a WS row.

INC ROW: (RS) K2, M1R, work in patt to end—1 st inc'd.

INC ROW: (WS) Work in patt to last 2 sts, M1L, K2—1 st inc'd.

Rep RS Inc row and WS Inc row 1 (1, 1, 2, 3) more time(s), using M1RP and M1LP in place of M1R and M1L if the Inc row is a WS purl row—59 (63, 67, 70, 76) sts.

Cut yarn and place Right Front Shoulder sts on holder.

Shape Left Front Shoulder

ROW 1: With RS facing and CO edge at the top, beg at removable marker placed at left neck edge, pick up and knit 20 (20, 24, 24, 24) sts from CO edge. Turn work.

ROW 2: (WS) K2, purl to last 2 sts, k2.

SHORT-ROW 3: (RS) K7 (7, 8, 8, 8), turn.

SHORT-ROW 4: Sl 1 & mark loop, purl to last 2 sts, k2.

SHORT-ROW 5: Knit to previous turning point, knit loop tog with st, k6 (6, 7, 7, 7), turn.

SHORT-ROW 6: Sl 1 & mark loop, purl to last 2 sts, k2.

ROW 7: Knit to previous turning point, knit loop tog with st, knit to end.

NEXT ROW: (WS) Knit to end.

Work Lace Stripe over next 12 rows.

Shape Left Neck (Plain Stripe)

ROW 1: (RS) K2, M1R, knit to end—1 st inc'd.

ROW 2: (WS) K2, purl to last 2 sts, k2.

ROW 3: Rep Row 1—1 st inc'd.

ROW 4: Rep Row 2.

ROW 5: Pm and, using cable method, CO 29 (33, 33, 33, 37) sts; knit to m, k2, M1R, knit to end.

ROW 6: Knit, removing m—52 (56, 60, 60, 64) sts.

Work Garter Stripe over next 2 rows.

Work Plain Stripe (without shaping) over next 6 rows.

Work 8 (12, 16, 16, 16) more rows in Stripe Sequence (Lace Stripe, Plain Stripe, Garter Stripe, Plain Stripe), until piece measures 5¾ (6¼, 6¾, 6¾, 6¾)" (14.5 [16, 17, 17, 17] cm) from CO, measured at armhole edge.

Shape Left Armhole

INC ROW: Work in patt to last 2 sts, M1L, k2—1 st inc'd.

Rep Inc row every other row 2 (2, 2, 3, 3) more times, ending with a WS row.

INC ROW: (RS) Work in patt to last 2 sts, M1L, k2—1 st inc'd.

INC ROW: (WS) K2, M1R, work in patt to end—1 st inc'd.

Rep RS Inc row and WS Inc row 1 (1, 1, 2, 3) more time(s), using M1RP and M1LP in place of M1R and M1L if the Inc row is a WS purl row—59 (63, 67, 70, 76) sts.

Do not cut yarn.

JOIN FRONTS AND BACK

NEXT ROW: (RS) Work in patt across Left Front sts, CO 1 (5, 5, 6, 8) st(s) using backward-loop method, pm for side seam, CO 1 (5, 7, 8, 10) st(s) using backward-loop method, work in patt across Back sts, CO 1 (5, 7, 8, 10) st(s) using backwards-loop method, pm for side seam, CO 1 (5, 5, 6, 8) st(s) using backward-loop method, work in patt to end—208 (236, 252, 272, 300) sts.

Work remainder of body to hem in Stripe Sequence as established (Lace Stripe, Plain Stripe, Garter Stripe, Plain Stripe), but work Garter Stripe with Short-rows in place of Garter Stripe as follows:

Garter Stripe with Short-rows

SHORT-ROW 1: (RS) K10, turn.

SHORT-ROW 2: (WS) Sl 1 & mark loop, purl to last 2 sts, k2.

SHORT-ROW 3: Knit to previous turning point, knit loop tog with st, k9, turn.

SHORT-ROW 4: Sl 1 & mark loop, purl to last 2 sts, k2.

SHORT-ROW 5: Knit to previous turning point, knit loop tog with st, k9, turn.

SHORT-ROW 6: Sl 1 & mark loop, purl to last 2 sts, k2.

SHORT-ROW 7: Knit to 8 sts past first marker, turn.

SHORT-ROW 8: Sl 1 & mark loop, purl to 6 sts past marker, turn.

SHORT-ROW 9: Sl 1 & mark loop, knit to previous turning point, knit loop tog with st, k7, turn.

SHORT-ROW 10: Sl 1 & mark loop, purl to previous turning point, purl loop tog with st, p5, turn.

Rep Short-rows 9 and 10 three more times.

SHORT-ROW 11: Knit to previous turning point, knit loop tog with st, knit to 6 sts past second marker, turn.

SHORT-ROW 12: Sl 1 & mark loop, purl to 8 sts past marker, turn.

SHORT-ROW 13: Sl 1 & mark loop, knit to previous turning point, knit loop tog with st, k5, turn.

SHORT-ROW 14: Sl 1 & mark loop, purl to previous turning point, purl loop tog with st, p7, turn.

Rep Short-rows 13 and 14 three more times.

SHORT-ROW 15: Knit to previous turning point, knit loop tog with st, knit to end.

SHORT-ROW 16: K2, p8, turn.

SHORT-ROW 17: Sl 1 & mark loop, knit to end.

SHORT-ROW 18: K2, purl to previous turning point, purl loop tog with st, p9, turn.

SHORT-ROW 19: Sl 1 & mark loop, knit to end.

SHORT-ROW 20: K2, purl to previous turning point, purl loop tog with st, p9, turn.

SHORT-ROW 21: Sl 1 & mark loop, knit to end.

Knit 1 row, working rem loops tog with sts.

Work Stripe Sequence with short-rows 4 times, then rep Lace Stripe and Plain Stripe once more.

Knit 1 row.

BO all sts knitwise on WS.

FINISHING

Weave in ends and block. Sew buttons at neck edge of Left Front, placing 1 at each end of CO left front neck stitches, aligned with buttonholes.

Chapter Five

THE TWIN-STITCH METHOD

The twin-stitch method, also called the shadow-wrap method, is a simple way to work short-rows in stockinette stitch, both back and forth and in the round. It also works well in ribbing or a pattern stitch with similar stacked stitches. In the twin-stitch method, stitches are worked to the desired turning point, then a "twin" to the following stitch is created by working into the stitch below with the working yarn, before turning the work. This book uses the abbreviation "twin&t" as the instruction to create a twin stitch and turn the work. On a subsequent row, the twin stitches are worked together, to disguise the turning point.

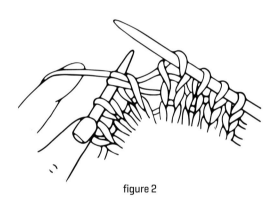

figure 1

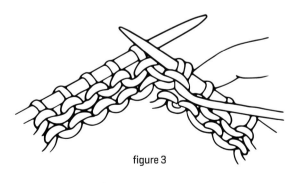

figure 2

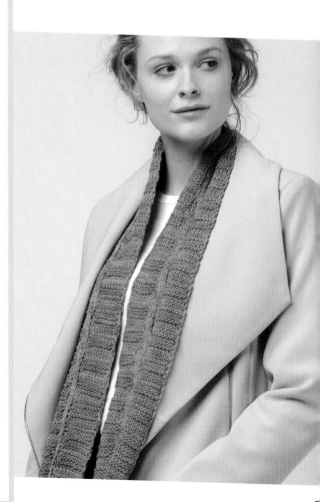

figure 3

THE TWIN-STITCH METHOD ON A KNIT ROW

1 Knit to the turning point; insert the right needle tip knitwise under the front leg of the next stitch and knit, creating a twin to the stitch on the left needle (**Figure 1**). If you find it difficult to knit through the front leg, use the right needle tip to place it on the left needle untwisted and then knit.

2 Place the twin stitch on the left needle, without twisting it (**Figure 2**).

3 Turn the work and work the next row. If you're working in stockinette stitch, leave the yarn at the front and purl the next row (**Figure 3**). If you're working in garter stitch, move the yarn to the back after you turn the work and knit the next row.

THE TWIN-STITCH METHOD ON A PURL ROW

1　Purl to the turning point; slip the next stitch purlwise to the right needle, then insert the left needle tip into the stitch below the slipped stitch on the right needle, lifting it onto the left needle (**Figure 1**).

2　Purl into this stich with the right needle, creating a twin to the stitch on the right needle (**Figure 2**).

3　Slip both the twin and the stitch from the right needle to the left needle (**Figure 3**).

4　Turn the work and work the next row. If you're working in stockinette stitch, leave the yarn at the back and knit the next row (**Figure 4**). If you're working in garter stitch, every row is a knit row, and you'll be following the steps for twin&t on a knit row instead.

Each twin stitch creates an extra loop on the needle, which must be eliminated to preserve the correct stitch count. On the subsequent row, simply work the twin loop together with its companion stitch.

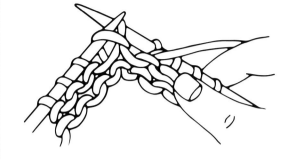

figure 1

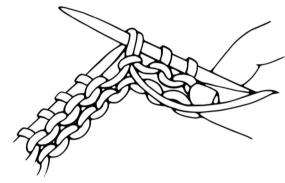

figure 2

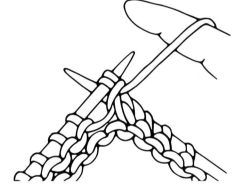

figure 3

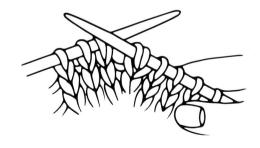

figure 4

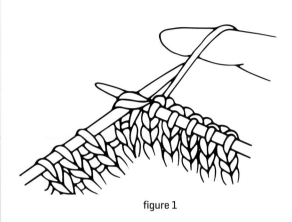

figure 1

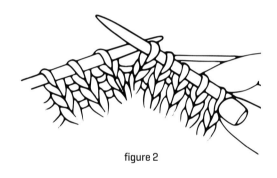

figure 2

TO WORK THE TWIN ON A KNIT ROW

1 Knit to the twin and its stitch and insert the right needle tip knitwise into both (**Figure 1**).

2 Knit both loops together as one (**Figure 2**).

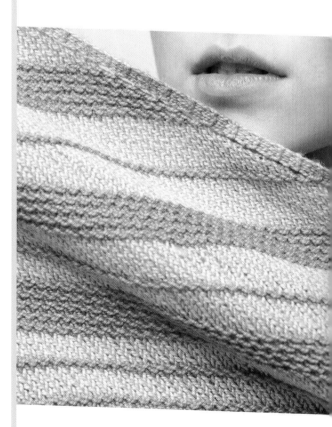

TO WORK THE TWIN
ON A PURL ROW

1　Purl to the twin and its stitch and insert the right needle tip purlwise into both (**Figure 1**).

2　Purl both loops together as one (**Figure 2**).

The twin-stitch method is simple to work, in both creating the extra loop that will disguise the turning point and in working that loop together with its twin. On the purl side in particular, when working the twin together with its stitch, the extra loop is easy to see; on the knit side, the loops might appear slightly more separated—just look at the row below to find the place where 2 loops originate from one stitch.

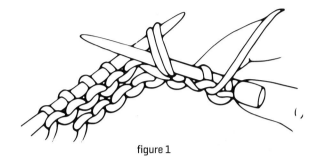

figure 1

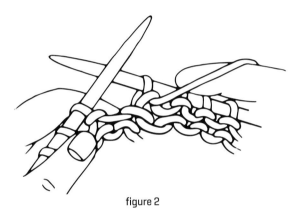

figure 2

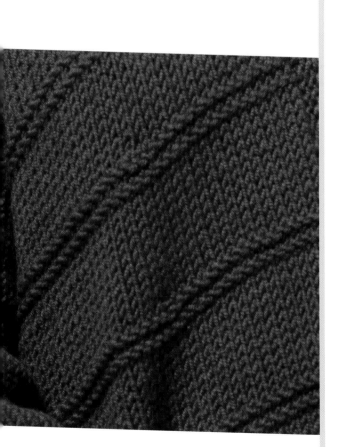

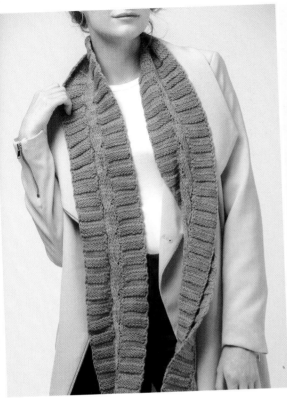
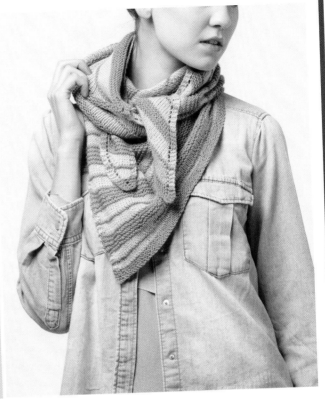

SPECIAL CONSIDERATIONS

The twin-stitch method looks great on the knit side of stockinette stitch and is also effective on the purl side, often depending on the fiber type and gauge used. It is simple to work and may also be used when knitting stockinette in the round, with no special accommodation necessary.

Since this method relies on working a stitch into the row below at the turning point, some distortion necessarily results when that stitch is pulled in an atypical way. In stockinette, the effect is minimal unless you're working at a super-bulky gauge or with very inflexible yarn, but in garter stitch, the effect is more noticeable between the alternating knit and purl rows.

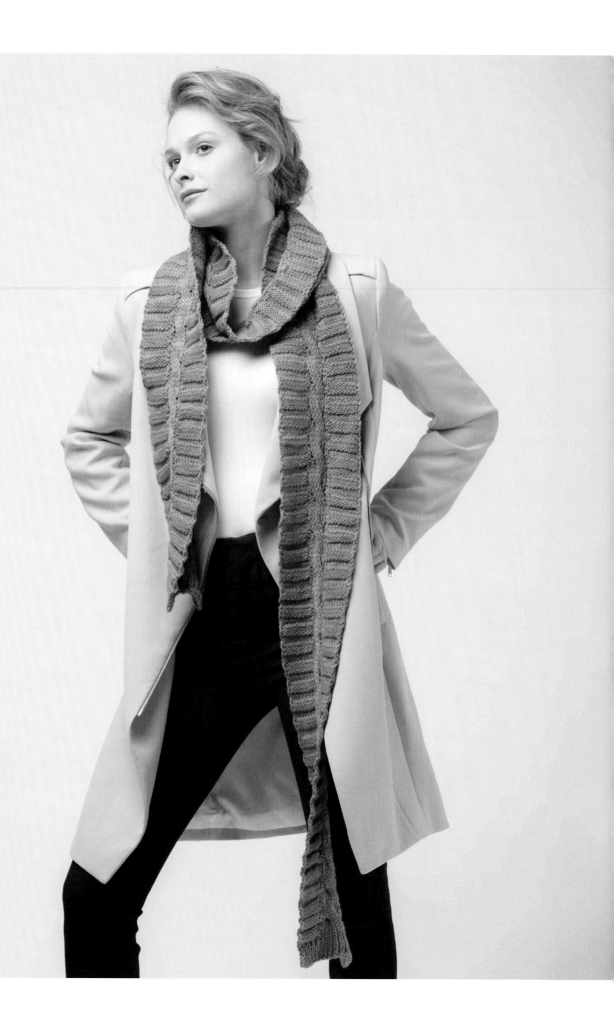

rumble strips
SCARF

Simple knit and purl stitches create textured welts worked with short-rows using the twin-stitch method. The double row of welted ruffles flanks a ribbed cable in this entirely reversible scarf.

FINISHED SIZE
About 86" [218 cm] long and 6" [15 cm] wide.

YARN
Worsted weight [#4 Medium].

Shown here: Swans Island Natural Colors Merino Worsted [100% merino wool; 250 yd [229 m]/3½ oz [100 g]]: Vintage Lilac, 2 skeins.

NEEDLES
Size U.S. 8 [5 mm]: straight. *Adjust needle size if necessary to obtain the correct gauge.*

NOTIONS
2 stitch markers [m, optional]; cable needle [cn]; yarn needle.

GAUGE
18 sts and 24 rows = 4" [10 cm] in St st.

Notes

I slipped the first stitch of every row for a neat edge. To do this, slip the stitch as it appears—slip a knit stitch knitwise wyb and a purl stitch purlwise wyf, then move the yarn into position as needed.

Stitch Guide

Twin&t (on a knit row): Work twin stitch and turn—insert right needle tip knitwise under the front leg of stitch below next stitch and knit, then place twin stitch on left needle, turn work.

Twin&t (on a purl row): Work twin stitch and turn—sl 1 purlwise, insert left needle tip into the stitch below slipped stitch and purl, then slip both stitches back to left needle, turn work.

6/6 LC: Slip 6 sts to cn and hold in front, [k1, p1] 3 times, [k1, p1] 3 times from cn.

K1, P1 RIB (worked flat, multiple of 2 sts)
Row 1: Sl 1 knitwise wyb, [p1, k1] to last st, p1.

Rep Row 1 for patt.

CABLE (worked over 12 sts)
Rows 1–4: [K1, p1] 3 times.

Row 5: [RS] 6/6 LC.

Rows 6–8: [K1, p1] 3 times.

SCARF

Using alternate cable method (see Techniques), CO 32 sts.

Work in K1, P1 Rib for 6 rows, place marker (pm) after first 10 sts and before last 10 sts on final Rib row if desired.

SHORT-ROW 1: Sl 1 knitwise wyb, p8, twin&t.

SHORT-ROW 2: Knit to end.

ROW 3: Sl 1 purlwise wyf, purl to twin st, purl twin tog with st, [k1, p1] 6 times, purl to end.

SHORT-ROW 4: Sl 1 knitwise wyb, k8, twin&t.

SHORT-ROW 5: Purl to end.

ROW 6: Sl 1 knitwise wyb, knit to twin st, knit twin tog with st, [k1, p1] 6 times, knit to end.

SHORT-ROW 7: Sl 1 purlwise wyf, k8, twin&t.

SHORT-ROW 8: Purl to end.

ROW 9: Sl 1 knitwise wyb, knit to twin st, knit twin tog with st, [k1, p1] 6 times, knit to end.

SHORT-ROW 10: Sl 1 purlwise wyf, p8, twin&t.

SHORT-ROW 11: Knit to end.

ROW 12: Sl 1 purlwise wyf, purl to twin st, purl twin tog with st, [k1, p1] 6 times, purl to end.

SHORT-ROW 13: Sl 1 knitwise wyb, p8, twin&t.

SHORT-ROW 14: Knit to end.

ROW 15: Sl 1 purlwise wyf, purl to twin st, purl twin tog with st, 6/6 LC, purl to end.

SHORT-ROW 16: Sl 1 knitwise wyb, k8, twin&t.

SHORT-ROW 17: Purl to end.

ROW 18: Sl 1 knitwise wyb, knit to twin st, knit twin tog with st, [k1, p1] 6 times, knit to end.

SHORT-ROW 19: Sl 1 purlwise wyf, k8, twin&t.

SHORT-ROW 20: Purl to end.

ROW 21: Sl 1 knitwise wyb, knit to twin st, knit twin tog with st, [k1, p1] 6 times, knit to end.

SHORT-ROW 22: Sl 1 purlwise wyf, p8, twin&t.

SHORT-ROW 23: Knit to end.

ROW 24: Sl 1 purlwise wyf, purl to twin st, purl twin tog with st, [k1, p1] 6 times, purl to end.

REP THESE 24 ROWS 45 MORE TIMES OR TO DESIRED LENGTH, THEN REP ROWS 1–6 ONCE MORE.

NEXT ROW: Sl 1 purlwise wyf, [p1, k1] to last st, p1.

Work in K1, P1 Rib for 5 more rows.

BO all sts in Rib pattern.

FINISHING

Weave in ends.

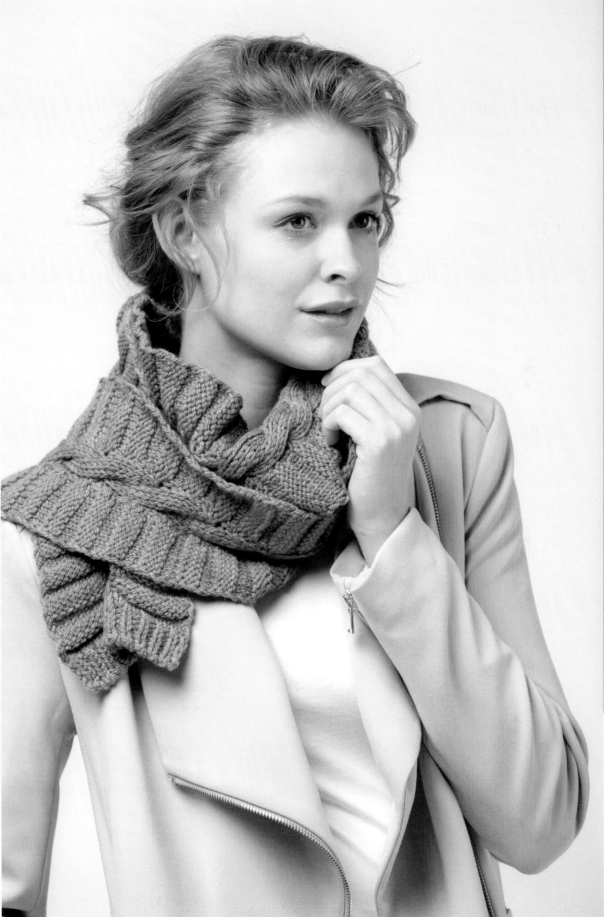

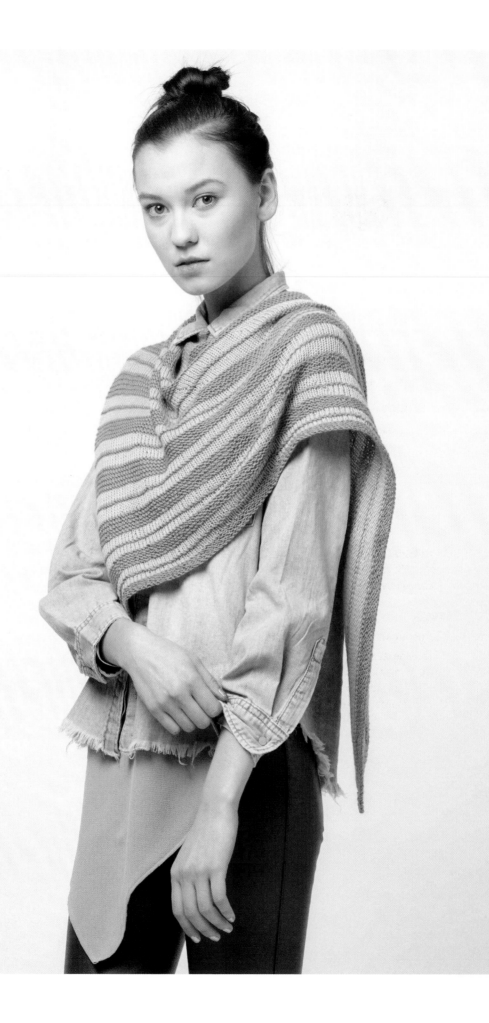

spokes SHAWL

An asymmetric sideways-knit wrap
alternates garter-stitch spokes in two widths,
with subtle stockinette wedges created with
the-twin stitch method on the purl rows.

FINISHED SIZE
About 70" [178 cm] wide and 22"
[56 cm] deep.

YARN
Fingering weight [#1 Super Fine].

Shown here: Shibui Staccato [70%
superwash merino wool, 30% silk;
191 yd [175 m]/1¾ oz [50 g]]: Clay
[MC] and Ash [CC], 2 skeins each.

NEEDLES
Size U.S. 6 [4 mm]: 32" [80 cm]
circular [cir]. *Adjust needle size if
necessary to obtain the correct
gauge.*

NOTIONS
Yarn needle.

GAUGE
16 sts and 32 rows = 4" [10 cm] in
garter st.

Notes

Follow the table for the values of x and y in each additional rep, to determine the number of stitches to work before turning the short-rows.

wedge	x	y	total sts at end of wedge
1	2	4	16
2	6	10	29
3	10	16	42
4	14	22	55
5	18	28	68
6	22	34	81
7	26	40	94
8	30	46	107
9	34	52	120
10	38	58	133
11	42	64	146
12	46	70	159
13	50	76	172

There is no need to cut the yarn; carry the unused color at the edge by twisting yarns at the beginning of RS rows.

Circular needle is used to accommodate large number of sts. Do not join; work back and forth in rows.

Stitch Guide

Twin&t (on a purl row): Work twin stitch and turn—sl 1 purlwise, insert left needle tip into the stitch below slipped stitch and purl, then slip both stitches back to left needle, turn work.

SHAWL

Set-up
Using long-tail method and MC, CO 4 sts.

SET-UP ROW 1: Knit.

SET-UP ROW 2: K1, yo, k3—5 sts.

SET-UP ROW 3: Knit.

SET-UP ROW 4: K2, yo, k3—6 sts.

SET-UP ROW 5: Knit.

SET-UP ROW 6: Knit to last 3 sts, yo, k3—7 sts.

SET-UP ROW 7: Knit.

Rep Set-up rows 6 and 7 once more—8 sts.

Stockinette Wedge
CC First Half

ROW 1: (RS) Knit to last 3 sts, yo, k3—1 st inc'd.

ROW 2: (WS) K3, purl to last 3 sts, k3.

ROW 3: Knit to last 3 sts, yo, k3—1 st inc'd.

SHORT-ROW 4: K3, p(x), twin&t.

SHORT-ROW 5: Knit to last 3 sts, yo, k3—1 st inc'd.

SHORT-ROW 6: K3, p(y), working twin tog with st, twin&t.

SHORT-ROW 7: Knit to last 3 sts, yo, k3—1 st inc'd.

ROW 8: K3, purl to last 3 sts, working twin tog with st, k3.

MC Skinny Spoke

ROW 1: Knit.

ROW 2: Knit.

CC Second Half

ROW 1: (RS) Knit to last 3 sts, yo, k3—1 st inc'd.

SHORT-ROW 2: K3, p(y), twin&t.

SHORT-ROW 3: Knit to last 3 sts, yo, k3—1 st inc'd.

SHORT-ROW 4: K3, p(x), twin&t.

SHORT-ROW 5: Knit to last 3 sts, yo, k3—1 st inc'd.

ROW 6: K3, purl to last 3 sts, working twins tog with sts, k3.

ROW 7: Knit to last 3 sts, yo, k3—1 st inc'd.

ROW 8: K3, purl to last 3 sts, k3.

MC Wide Spoke

ROW 1: Knit to last 3 sts, yo, k3—1 st inc'd.

ROW 2: Knit.

Rep Rows 1 and 2 four more times—4 more sts inc'd.

Work Stockinette Wedge and Wide Spoke 12 more times, turning short-rows according to table, and binding off all sts on the final Wide Spoke row.

FINISHING

Weave in ends and block.

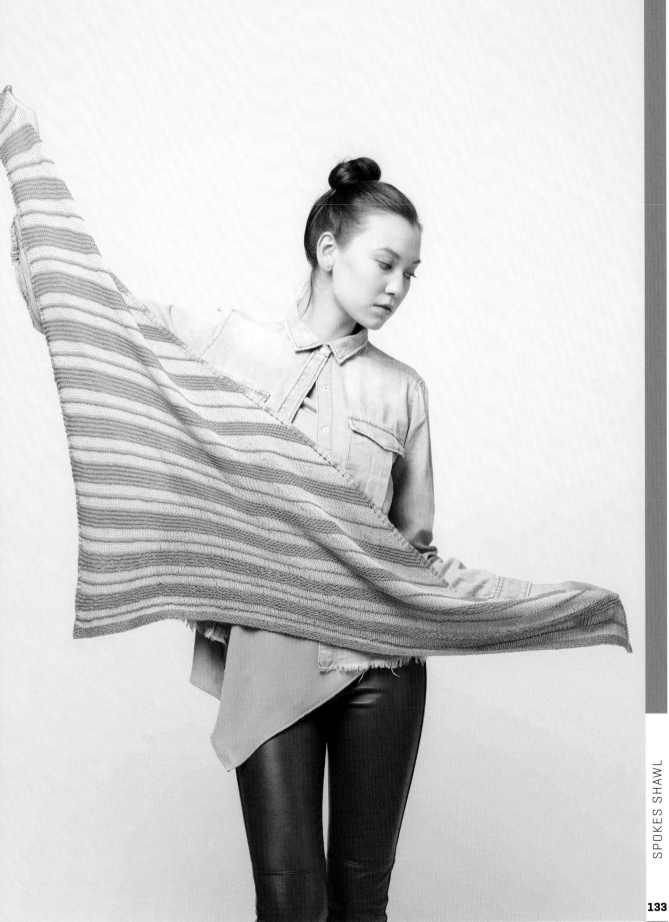

radial RAGLAN

Subtle short-rows worked using twin stitches shape the back of the Radial Raglan, which uses modified raglan construction worked seamlessly from the top down. A series of gentle short-rows radiate from the center back, lengthening as the sweater is worked toward the hem and accenting the longer back and the diagonal front edges; similar short-rows curve the cuffs, and additional short-rows shape the narrow garter front edging.

FINISHED SIZE
About 32 [36, 40½, 44, 48]" [81.5 [91.5, 103, 112, 122] cm] bust circumference, based on 2 times the back width. Sweater shown measures 36" [91.5 cm].

YARN
DK weight [#3 Light].

Shown here: Valley Yarns Northfield [70% merino, 20% baby alpaca, 10% silk; 124 yd [113 m]/1¾ oz [50 g]]: Summer Plum, 10 [11, 12, 13, 14] balls.

NEEDLES
Size U.S. 7 [4.5 mm]: 32" [80 cm] and 60" [150 cm] circular [cir]. *Adjust needle size if necessary to obtain the correct gauge.*

NOTIONS
7 stitch markers [m], 1 in a different color [mB]; stitch holders; yarn needle.

GAUGE
19 sts and 26 rows = 4" [10 cm] in St st; 19 sts and 32 rows = 4" [10 cm] in garter st.

Notes

The back and sleeves are worked in the raglan style to the bottom of the armholes, then the body and sleeves are divided and stitches are picked up along the front raglan lines and united with the back. The radiating short-rows add length and accent the diagonal front edges of the cardigan, which are shaped further with increases. The body is finished with garter stitch; sleeves are worked seamlessly in the round to complementary short-row cuffs. The front edges and neckline are picked up and finished simply with a short-row garter-stitch collar.

Radial is meant to be worn open; the angled fronts will not meet at the bust, but will overlap at the hem if placed flat. The back is longer than the front, with an angled front hem.

Stitch Guide

Twin&t (on a knit row): Work twin stitch and turn—insert right needle tip knitwise under the front leg of stitch below next stitch and knit, then place twin stitch on left needle, turn work.

Twin&t (on a purl row): Work twin stitch and turn—sl 1 purlwise, insert left needle tip into the stitch below slipped stitch and purl, then slip both stitches back to left needle, turn work.

4-ROW GARTER STRIPE

Inc row: [RS] [Knit to 1 st before m, k1f&b, sl m] 3 times, ignoring mB at center back, [knit to next m, sl m, k1f&b] 3 times, knit to end—6 sts inc'd.

Knit 3 rows.

SLEEVE 4-ROW GARTER DECREASE STRIPE

Dec rnd: K1, k2tog, knit to last 3 sts, ssk, k1—2 sts dec'd.

Rnd 2: Purl.

Rnd 3: Knit.

Rnd 4: Purl.

BACK AND SLEEVES

Using cable method (see Techniques), CO 58 (64, 70, 72, 76) sts.

SET-UP ROW: (WS) P4, place marker (pm), p10 (10, 12, 12, 12), pm, p2, pm, p26 (32, 34, 36, 40), pm, p2, pm, p10 (10, 12, 12, 12), pm, p4.

INC ROW: (RS) *Knit to m, sl m, M1R, knit to m, M1L, sl m; rep from * 2 times, knit to end—6 sts inc'd.

ROW 2: Purl.

Rep last 2 rows 22 (24, 26, 29, 31) more times, binding off 2 sts at beg of last WS row. Piece measures about 7¼ (7¾, 8½, 9¼, 10)" (18.5 [19.5, 21.5, 23.5, 25.5] cm) from beg of raglan shaping.

NEXT ROW: (RS) BO first 2 sts, cut yarn—192 (210, 228, 248, 264) sts rem: 56 (60, 66, 72, 76) sts each sleeve, 72 (82, 88, 96, 104) back sts, and 8 sts for raglan seam lines.

FRONT, DIVIDE BODY AND SLEEVES

NEXT ROW: (RS) Using new yarn and beg at neck edge of left front raglan seam line, pick up and knit 34 (38, 40, 44, 48) sts along left front raglan edge, k2 raglan sts, sl m; place 56 (60, 66, 72, 76) left sleeve sts on holder and remove m; CO 0 (0, 2, 2, 3) sts using backward-loop method; k2 raglan sts, remove m and knit to next m; remove m and k2 raglan sts, remove m and place 56 (60, 66, 72, 76) right sleeve sts on another holder; CO 0 (0, 2, 2, 3) sts; sl m, k2

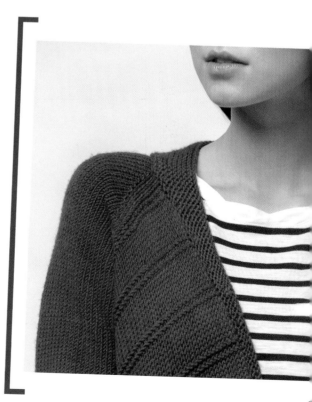

raglan sts; pick up and knit 34 (38, 40, 44, 48) sts along right front raglan edge—148 (166, 180, 196, 214) sts rem for body: 36 (40, 42, 46, 50) sts each front, 76 (86, 96, 104, 114) back sts.

SET-UP ROW: (WS) K12 (14, 14, 16, 17), pm, k12 (13, 14, 15, 17), pm, k12 (13, 14, 15, 16) to m, sl m, k38 (43, 48, 52, 57), pmB, knit to m, sl m, k12 (13, 14, 15, 16), pm, k12 (13, 14, 15, 17), pm, k12 (14, 14, 16, 17) to end.

INC ROW: (RS) [Knit to 1 st before m, k1f&b, sl m] 3 times, ignoring mB at center back, [knit to next m, sl m, k1f&b] 3 times, knit to end—6 sts inc'd.

NEXT ROW: (WS) Knit.

Radial Stripe

SHORT-ROW 1: (RS) Knit to mB, k10 (11, 11, 12, 13), twin&t.

SHORT-ROW 2: (WS) Purl to mB, p10 (11, 11, 12, 13), twin&t.

Knit to end, working twin tog with st.

Work 7 more rows in St st, working twin tog with st on first row.

Work 4-Row Garter Stripe—6 sts inc'd.

Rep Radial Stripe 2 more times, working 10 (11, 11, 12, 13) sts further than previous Short-rows 1 and 2 each time; then rep Radial Stripe 3 times, working 10 (11, 11, 12, 13) sts further than previous Short-rows 1 and 2 each time AND 2 additional rows (9 rows) in St st before the Garter Stripe; then rep Radial Stripe 3 more times, working 10 (11, 11, 12, 13) sts further than previous Short-rows 1 and 2 each time AND 2 additional rows (11 rows) in St st before the Garter Stripe—208 (226, 240, 256, 274) sts: 66 (70, 72, 76, 80) sts each front, 76 (86, 96, 104, 114) back sts.

Hem

Knit 7 rows.

Bind off all sts knitwise on WS.

SLEEVES

With RS facing and new yarn, beg in middle of CO underarm sts of body, pick up and knit 0 (0, 1, 1, 2) st(s) from underarm, knit 56 (60, 66, 72, 76) sleeve st(s) from holder, pick up and knit 0 (0, 1, 1, 2) st(s) from underarm, pm and join for working in the rnd—56 (60, 68, 74, 80) sts.

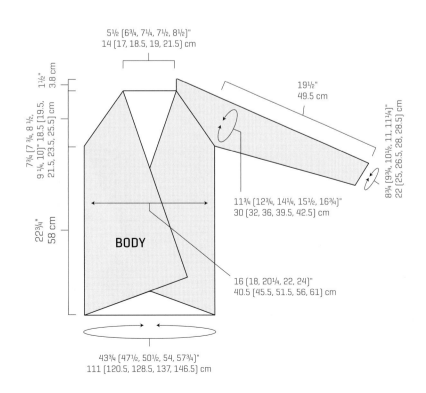

5½ [6¾, 7¼, 7½, 8½]"
14 [17, 18.5, 19, 21.5] cm

1½"
3.8 cm

7¾ [7 ¾, 8 ½, 9 ¼, 10]" 18.5 [19.5, 21.5, 23.5, 25.5] cm

19½"
49.5 cm

8¾ [9¾, 10¼, 11, 11¼]" 22 [25, 26.5, 28, 28.5] cm

BODY

11¾ [12¾, 14¼, 15½, 16¾]"
30 [32, 36, 39.5, 42.5] cm

16 [18, 20¼, 22, 24]"
40.5 [45.5, 51.5, 56, 61] cm

22¾"
58 cm

43¾ [47½, 50½, 54, 57¾]"
111 [120.5, 128.5, 137, 146.5] cm

Knit 18 (18, 12, 8, 6) rnds.

DEC RND: K1, k2tog, knit to last 3 sts, ssk, k1—2 sts dec'd.

Rep Dec rnd every 19 (19, 13, 9, 7) rnds 1 (1, 5, 1, 1) more time(s), then every 20 (20, 14, 10, 8) rnds 2 (2, 0, 6, 8) times—48 (52, 56, 58, 60) sts rem.

Cuff
Right Cuff
SET-UP RND: K28 (32, 36, 38, 38), pm, knit to end.

Left Cuff
SET-UP RND: K20 (20, 20, 20, 22), pm, knit to end.

NEXT RND: Purl.

NEXT RND: Knit.

NEXT RND: Purl.

Cuff Radial Stripe
SHORT-ROW 1: (RS) Knit to m, k6 (6, 7, 7, 7), twin&t.

SHORT-ROW 2: (WS) Purl to m, p6 (6, 7, 7, 7), twin&t.

Knit to end.

Work 7 more rnds in St st, working twins tog with sts.

Work Sleeve 4-Row Garter Decrease Stripe—2 sts dec'd.

Rep Cuff Radial Stripe 2 more times, working 4 sts further than previous Short-rows 1 and 2 each time AND 2 additional rnds (9 rnds and 11 rnds) in St st before the Garter Decrease Stripe each time—42 (46, 50, 52, 54) sts rem.

Knit 1 rnd.

Bind off all sts purlwise.

FINISHING
Front Edging and Collar
Weave in any ends along front and neck edges before working the edging.

With RS facing and using working yarn, pick up and knit 105 sts along right front edge, 2 sts from raglan, 10 (10, 12, 12, 12) sts from right sleeve at neckline, 2 sts from raglan, pm, 26 (32, 34, 36, 40) sts from back neck, pm, 2 sts from raglan,

10 (10, 12, 12, 1 2) sts from left sleeve at neckline, 2 sts from raglan, and 105 sts along left front edge—264 (270, 276, 278, 282) sts.

NEXT ROW: (WS) Knit.

SET-UP SHORT-ROW 1: (RS) Knit to second marker, twin&t.

SET-UP SHORT-ROW 2: (WS) Purl to marker, twin&t.

SHORT-ROW 1: Knit to twin, work twin tog with st, k4, twin&t.

SHORT-ROW 2: Purl to twin, work twin tog with st, p4, twin&t.

Rep Short-rows 1 and 2 seven more times.

Knit to end, working twin tog with st.

NEXT ROW: (WS) Knit, working twin tog with st.

NEXT ROW: (RS) Knit.

Bind off all sts knitwise on WS.

Weave in rem ends and block.

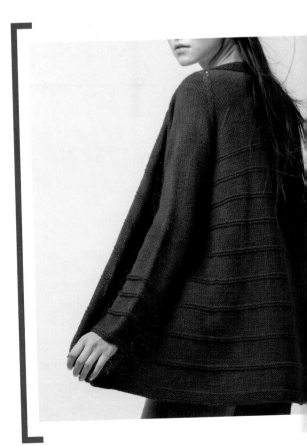

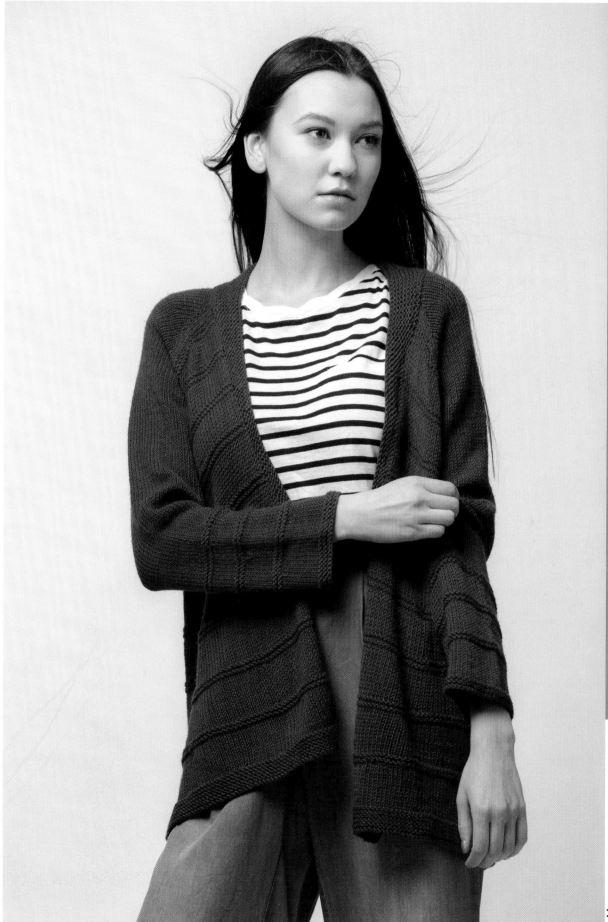

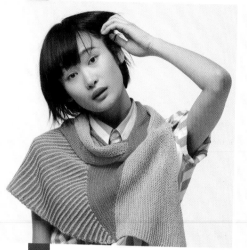
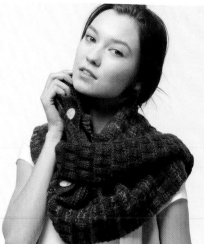
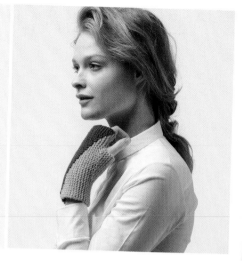

SUBSTITUTING METHODS AND CONVERTING INSTRUCTIONS

With an understanding of the different methods for working short-rows, you have a variety of techniques to employ, depending on the effect you wish to achieve, the placement of the short-rows and type of fabric, and the yarn and gauge with which you are working. These factors also might influence you to substitute a different method for the one written in a pattern's instructions, which can be done simply using your knowledge of the mechanics of each method.

All five methods of working short-rows are similar in that they create an extra loop of yarn at the short-row turning point, which is later worked together with a stitch of the fabric bordering the turning point, to close the gap created by turning. Occasionally a short-row might be worked with no special treatment at all at the turning point; for example, if the gap is being closed by a decrease working the stitches on either side together, but even in this instance, an extra loop of yarn can help further disguise the turning point. Typically, a special technique is employed to create a smooth and gap-free fabric.

The differences among the various methods include whether the work is turned to the other side before or after creating the loop and how the loop is made. In the yarnover, German, Japanese, and twin methods, the work is first turned and then the extra loop is created. The yarnover method creates the loop by making a yarnover with the working yarn; the German method by converting a stitch on the needle into a double stitch; the Japanese method by only marking the working yarn

at this time, to be pulled into a loop later; and the twin method by creating a twin stitch with the working yarn from a stitch in the row below. Only the wrap & turn method creates the loop prior to turning, by wrapping a stitch on the needle with the working yarn. For this reason, when converting instructions from wrap & turn to another method, you must remember to work one additional stitch than is called for in the w&t instructions, before turning the work and employing the substituted technique. Likewise, if converting to w&t from another method, work one stitch fewer than the instructions indicate, then wrap & turn the next stitch.

Other than this adjustment when substituting methods, you only need to consider your particular fabric when deciding to employ another technique. Swatching with your yarn and needles will indicate whether the method you choose gives the result you want.

Some terminology you may encounter when following instructions for knitting short-rows includes "disguising the turning point," "closing the gap," "work to the previous wrapped stitch," "work to the previous turning point," and "work to x stitches before the previous gap." Pattern instructions often use the gap at the turning point, or the extra loops of previously created turning points, as milestone indicators when working subsequent short-rows. In most cases and with some familiarity with the method, you will recognize these points; you can always mark a gap or a stitch with a marker for ease of identification later, if you're having trouble recognizing it.

[ABBREVIATIONS]

beg begin[ning]

BO bind off

CC contrast color

cn cable needle

CO cast on

dec('d) decrease[d]

double st (German method on a knit row) yf between needles, sl 1, yb over needle

double st (German method on a purl row) sl 1, yb over needle, yf between needles

inc('d) increase[d]

k knit

k-tbl knit stitch through back loop

k1f&b knit into the front and back of same stitch

k2tog knit 2 stitches together

k2tog-tbl knit 2 stitches together through the back loops

m marker

M1L make one left

M1LP make one purl left

M1R make one right

M1RP make one purl right

MC main color

p purl

patt pattern

p1f&b purl into front and back of same stitch

pm place marker

p-tbl purl stitch through the back loop

rem remain[ing]

rep repeat[ing]

rnd(s) round[s]

RS right side

skp slip stitch knitwise, knit the next stitch, pass slipped stitch over knit stitch and off the right needle

sl slip

sl 1 & mark loop (Japanese method on a knit row) sl1 purlwise, place marker on working yarn at front of work, work next row.

sl 1 & mark loop (Japanese method on a purl row) sl1 purlwise, place marker on working yarn at back of work, work next row.

sl m slip marker

SR short-row

ssk slip, slip, knit

st(s) stitch[es]

St st Stockinette stitch

tbl through back loop

twin&t (on a knit row) work twin stitch and turn—insert right needle tip knitwise under the front leg of stitch below next stitch and knit, then place twin stitch on left needle, turn work.

twin&t (on a purl row) work twin stitch and turn—sl1 purlwise, insert left needle tip into the stitch below slipped stitch and purl, then slip both stitches back to left needle, turn work.

WS wrong side

w&t (on a knit row) wrap & turn stitch—slip stitch purlwise to right needle; move yarn to front, slip stitch back to left needle, turn work, move yarn to front; work the wrapped stitch together with its wrap on next row

w&t (on a purl row) wrap & turn stitch—slip stitch purlwise to right needle; move yarn to back, slip stitch back to left needle, turn work, move yarn to back; work the wrapped stitch together with its wrap on next row

wyb with yarn in back

wyf with yarn in front

yb move yarn to back of work

yf move yarn to front of work

yo yarnover

yo make backward yo (garter stitch)—bring yarn between needles to back, then over right needle to front, then between needles to back again and knit next row; (stockinette st, when the next row is a purl row)—bring yarn over right needle to back, then between needles to front again and purl next row

* repeat starting point (i.e. repeat from *)

() alternate measurements and/or instructions

[] instructions that are to be worked as a group a specified number of times

Acknowledgments

Thank you to my lovely family, who support creativity in all forms, always.

Also a profound hug of gratitude to my editors and the creative and technical team, for bringing this book to life.

Thank you as well to the yarn companies and dyers, for providing their wonderful support:

- Anzula
- Baah!
- Blue Sky Fibers
- Cascade
- Dream In Color
- Elsebeth Lavold
- Harrisville Designs
- HiKoo by Skacel
- Lorna's Laces
- Manos del Uruguay
- Shalimar Yarns
- Shibui
- String Theory Hand Dyed Yarn
- Swans Island
- The Fibre Company
- Valley Yarns

[TECHNIQUES]

CAST-ONS

Alternate Cable Cast-On

Place slipknot on left needle; insert right needle into slipknot and knit one stitch. Place this stitch on left needle without twisting. *With yarn in front, insert right needle between first and second stitches on left needle from back to front, purl one stitch and place on left needle without twisting; insert right needle between first and second stitches on left needle, knit one stitch and place on left needle without twisting; rep from * until total number of required CO stitches are on left needle, including the slipknot

Cable Cast-On

Place slipknot on left needle; insert right needle into slip knot and knit one stitch. Place this stitch on left needle without twisting. *With yarn in back, insert right needle between first and second stitches on left needle from front to back [Figure 1], wrap yarn around needle as if to knit, draw yarn through [Figure 2], and place on left needle without twisting [Figure 3]; rep from * until total number of required CO stitches are on left needle, including the slip knot.

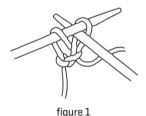

figure 1

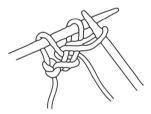

figure 2

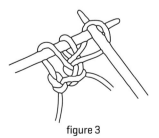

figure 3

Invisible Provisional Cast-On

Place slipknot on right needle. Hold scrap yarn next to slipknot below needle and under left thumb; hold working yarn over left index finger. *Bring needle forward under scrap yarn, over working yarn, grabbing a loop of working yarn [Figure 1], then bring needle to front over both yarns and grab a second loop [Figure 2], repeat from *. To work CO sts, remove scrap yarn and place live sts on needle.

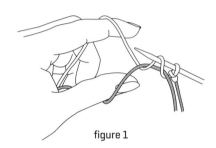

figure 1

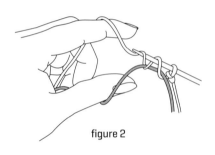

figure 2

METRIC CONVERSION CHART

To convert:	to:	multiply by:
Inches	Centimeters	2.54
Centimeters	Inches	0.4
Feet	Centimeters	30.5
Centimeters	Feet	0.03
Yards	Meters	0.9
Meters	Yards	1.1

SOURCES FOR YARNS

Anzula
anzula.com

Baah!
baahyarn.com

Blue Sky Fibers
PO Box 88
Minneapolis, MN 55011
blueskyfibers.com

Cascade
cascadeyarns.com

Dream In Color
dreamincoloryarn.com

Elsebeth Lavold
www.ingenkonst.se/textile.htm

Harrisville Designs
harrisville.com

HiKoo by Skacel
skacelknitting.com

Lorna's Laces
4229 North Honore Street
Chicago, IL 60613
lornaslaces.net

Fairmount Fibers/Manos del
Uruguay
PO Box 2082
Philadelphia, PA 19103
fairmountfibers.com

Shalimar Yarns
shalimaryarns.com

Shibui Knits
1500 NW 18th
Suite 110
Portland, OR 97209
shibuiknits.com

String Theory Hand Dyed Yarn

Swans Island
231 Atlantic Highway
Northport, ME 04849
swansislandcompany.com

The Fibre Company
Distributed by Kelbourne Woolens
2000 Manor Road
Conshohocken, PA 19428
kelbournewoolens.com

Valley Yarns
yarn.com/webs-knitting-crochet-
yarns-valley-yarns/

INDEX

Rock Your Knitting with These Resources from Interweave

The Art of Seamless Knitting

Simona Merchant-Dest and Faina Goberstein

9781596687882 | $26.99

Finish-Free Knits

No-Sew Garments in Classic Styles

Kristen TenDyke

9781596684881 | $24.95

Available at your favorite retailer or shop.knittingdaily.com

knittingdaily shop

 knittingdaily

Join KnittingDaily.com, an online community that shares your passion for knitting. You'll get a free eNewsletter, free patterns, a projects store, a daily blog, event updates, galleries, tips and techniques, and more. Sign up at **Knittingdaily.com.**

From cover to cover, *Interweave Knits* magazine presents great projects for the beginner to the advanced knitter. Every issue is packed full of captivating, smart designs, step-by-step instructions, easy-to-understand illustrations, plus well-written, lively articles sure to inspire. **Interweaveknits.com**